# CHINESE ORIGAMI
# PAPER FOLDING
## for Year-Round Celebrations

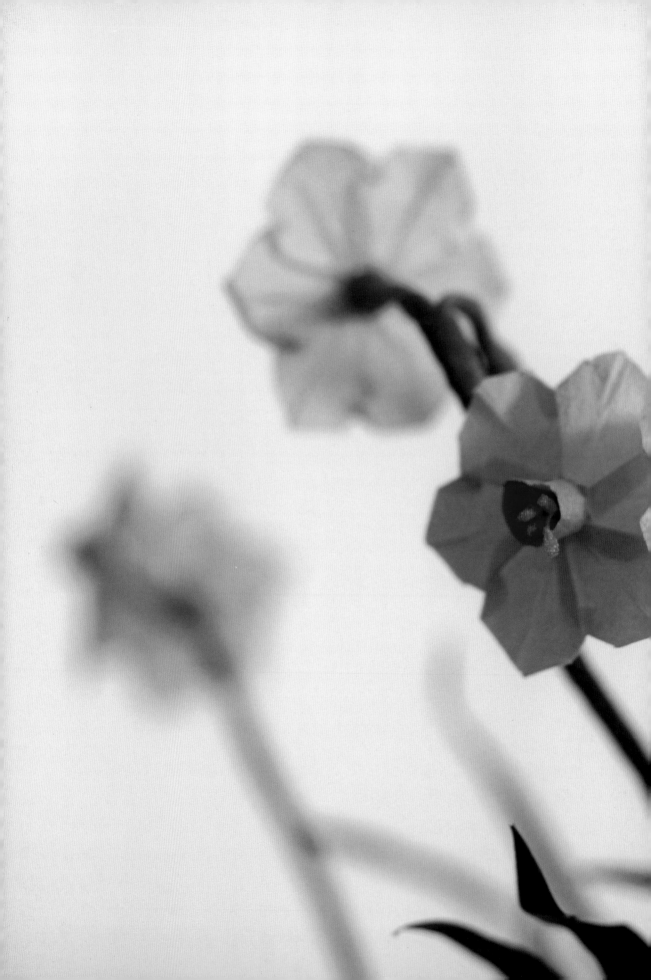

# CHINESE ORIGAMI
# PAPER FOLDING
## for Year-Round Celebrations

Chen Yuehua

etter Link Press

*On page 1*
It is customary to celebrate different traditional holidays with different flowers. For example, during the Spring Festival, essential home preparations include the clean, elegant narcissus and rich, red peonies. Every March, when spring flowers start to bloom, Chinese people celebrate the Festival of the Birth of Flowers. On this day, people enjoy planting and looking at flowers, and at night, "Lanterns for the Flower Gods" are hung on flowering branches to attract a year of blooming abundance.

*On pages 2–3*
The Chinese narcissus is viewed as a magical flower in China, having the ability to ward off evil and bring in fortune. Towards the end of each year, many people like to grow several pots of carefully trimmed narcissus. They time the planting precisely so the flowers would bloom on New Year's Eve or New Year's Day, denoting hopes for "fulfilled fortunes, abundant wealth and blissful joy." Some even put red ribbons on the stem, to symbolize "red with big fortune." In Chinese culture, the color red symbolizes abundance and luck.

*Right*
In China, fish is a symbol of plentiful bounty and luck. It can be found not only on the decorations but also on the New Year's dinners.

This book is edited and designed by the Editorial Committee of *Cultural China* series

Text and Works by Chen Yuehua
Diagrams by Tian Zengli
Translation by Kayan Wong
Photographs by Liu Shenghui
Front Cover Design by Wang Wei
Interior and Back Cover Design by Yuan Yinchang, Li Jing, Hu Bin (Yuan Yinchang Design Studio)

Copy Editor: Susan Luu Xiang
Editors: Yang Xiaohe, Wu Yuezhou
Editorial Director: Zhang Yicong

Senior Consultants: Sun Yong, Wu Ying, Yang Xinci
Managing Director and Publisher: Wang Youbu

ISBN: 978-1-60220-013-5

Address any comments about *Chinese Origami: Paper Folding for Year-Round Celebrations* to:

Better Link Press
99 Park Ave
New York, NY 10016
USA

or

Shanghai Press and Publishing Development Company
F 7 Donghu Road, Shanghai, China (200031)
Email: comments_betterlinkpress@hotmail.com

Printed in China by Shenzhen Donnelley Printing Co., Ltd.

1  3  5  7  9  10  8  6  4  2

# CONTENTS

# CONTENTS

*On facing page*
"Five Sons Rise to Excellence" is a folklore proverb and its auspicious meaning is often used as a blessing. In the ancient story, a Chinese family's five sons were all high academic achievers; one after another, they became government officials who helped the people. This proverb embodies the hopes of the Chinese for their sons to be great achievers with bright futures and ideals. In this artwork, the five colorful and adorable boys exhibit the rich styles and characters of Chinese folk art.

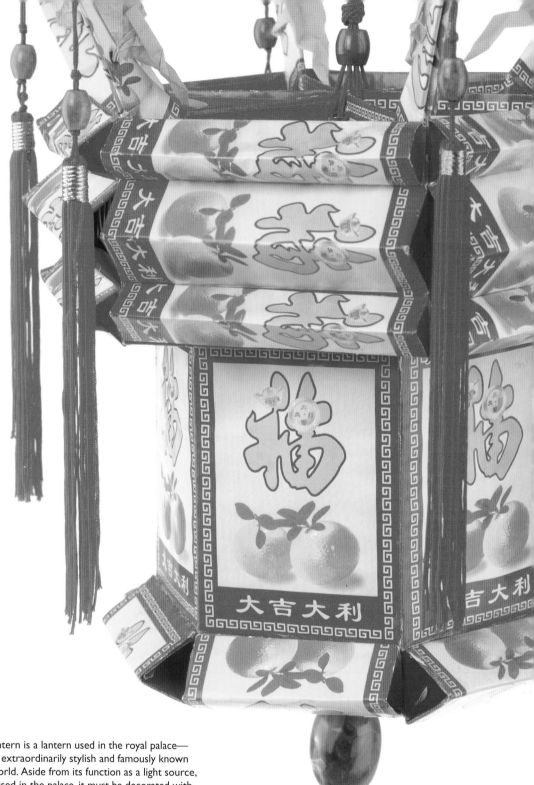

The palace lantern is a lantern used in the royal palace—
richly elegant, extraordinarily stylish and famously known
around the world. Aside from its function as a light source,
because it is used in the palace, it must be decorated with
delicate ornaments, while the paintings on the surface of
the lantern must also tell beautiful, meaningful stories.

To make this Fortune Dragon Palace Lantern, the
author used red envelopes printed with the character 福
(fortune) along with other materials. Six dragon heads
with red beards face six different directions. The lantern
symbolizes fortune and longevity, luck and fulfilled wishes.

# PREFACE

The art of paper folding is an exquisite craft, with paper as the main material, folded into artful pieces of different shapes. Not only is it healthy and calming for the senses, it fosters creativity and stretches the mind.

Although there are many different stories about the origins of the art of paper folding, scholars believe the art originated in China. Papermaking, one of the Four Great Inventions, provided the means for the early art of paper folding. Chinese scholars also found proof in ancient texts: in *The Twenty-Five Histories* there was record of "split paper into armor," describing how the Tang Dynasty folded and assembled paper into the outer shell of an armor while adding bark and cotton as filling. In addition, the

The cactus signifies endurance. The thorns on the surface make it an unusual plant among the botany world.

Dunhuang collection of folded paper art, currently stored in the British Museum, may be the oldest discovered works of paper-folding art in the world. The two folded paper flowers have eight blossoms including stamens, showing subtle craftsmanship.

During the mid-7th century, the Tang Empire was the most powerful and civilized country in the world, and it was during this time that the art of paper folding spread around the world. At the time, the Japanese gave it the name "origami": "ori" means folding, and "gami" means paper. The Japanese placed great importance on this art, promoting it further, with the art eventually spreading to Europe and the United States. Beginning in the 19th century, the art even became a tool for teaching and scientific research in the West.

Today, the art of paper folding is once again "heating up" in China, its birthplace. To create thousands of different shapes from a single piece of paper: that is the joy of paper folding. The art of paper folding is a process of hand-brain coordination, full of imagination and creativity. Everyone, let's move our hands, and share the fun!

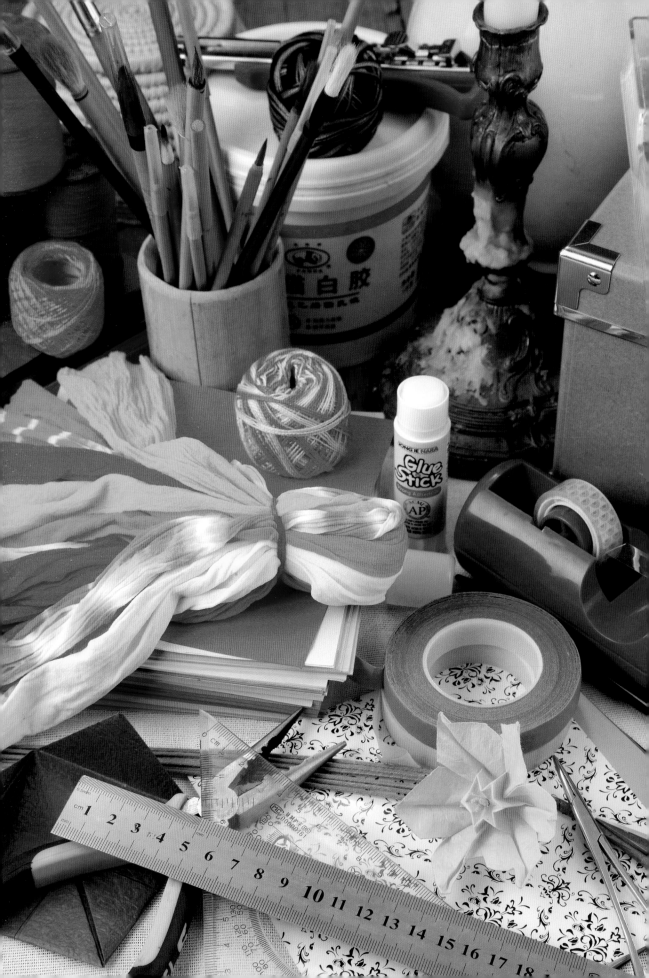

# Chapter 1

# PREPARATIONS

*Zhezhi,* by definition, is the art of paper folding. It goes without saying that paper is the most basic, most important material. Preparing the proper paper is of critical importance towards successfully creating art pieces. Also, with a little effort, scrap material can be reworked and incorporated to bring the folded paper art piece to life.

The tools needed for paper folding are not complicated; with good usage, they can improve the success rate of the finished work. Before folding, it is also important to become familiarized with the symbols and diagrams used in paper-folding instructions. In the process of folding, continually deepen the understanding of these symbols and legends; they may be your most important guides.

## PAPER SELECTION

The paper you choose will, to a large degree, determine the quality of your finished work. Whatever you want to create, the paper must match the work. Without thinking about this ahead of time, it is difficult to successfully obtain the expected results.

With paper selection, first consider the material; second, the thickness; and third, the proper size. Choose paper with malleability; otherwise, with more steps, the paper will be more likely to break. Paper size is also critical; pieces requiring many steps will require larger pieces of paper.

To get the desired beauty and effects, follow the theme of the art piece and choose the appropriate pattern and color. As for material, the most common papers are textured paper, color paper, wrapping paper, card stock, and crêpe paper. After several pieces of work, you will slowly gain experience in paper selection; you may have to sacrifice a few sheets of paper, but more importantly, over time you will get better at paper selection.

*On facing page*
The most important material in paper folding is the paper. With different choices of paper material, you can create a variety of effects in your projects. Combined with the use of accessories, projects can really come to life. In addition, tools provide delicate precision. In this book, you can find many tips in the sections with blue background.

## Color Paper

Color paper come in bright hues, rich patterns and a shiny smooth surface. Some come with color and patterns on both sides; others are plain white on one side. Color paper come in two finishes: matte (also called offset paper, similar to printer paper) and glossy (also called coat-finished paper). Color paper tends to be hard and brittle, with poor malleability, and is not suitable for complex projects that require multiple folds. With clever use of pattern and texture, you can highlight the theme and effect of your project with surprising results.

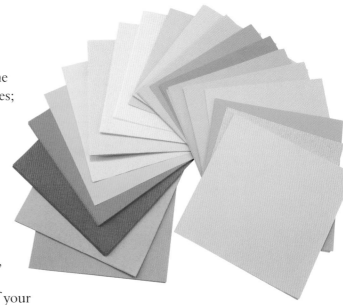

## Crêpe Paper

Crêpe paper has clear wrinkles and lines. Compared with textured paper, crêpe paper is softer, but is less malleable. Crêpe paper is great for flower projects; its elasticity means it can withstand being pulled, and is suitable for roses, morning glory, narcissus, calla lily, lotus, tulips, plum blossoms, etc.

## Textured Paper

Textured paper has bright color, clear lines, and a definite water resistance. Paper malleability is strong, performance is strong, and the price is relatively cheap. Textured paper is not brittle, and therefore is recommended for projects that require many folds. The only drawback is that, over time, the project may become loose and change shape.

## Calligraphy Paper

Calligraphy paper is extremely thin and soft, and is not suitable for beginners or children. Even though it is thin, it is quite tough. Most importantly, the color process for calligraphy paper creates brilliant hues that do not fade over time, which is something not achievable by regular processed paper. Therefore, many advanced paper cutting works utilize calligraphy paper, because they can be displayed in sunlight and never fade in color.

## Waxed Paper

Waxed paper surface is smooth and shiny; color appears bright, texture tends to be thin, and it creases well. Waxed paper has average toughness, and is not suitable for complex projects, but for more simple, colorful, fun gadgets.

## Card Stock

Card stock is a slightly thick paper, between regular paper and cardboard; paper surface is smooth, and quality is strong and durable. This type of paper is often used for stability and display purposes.

# ACCESSORIES

Want to add extra special touches on your projects? Consider using accessories.

## Color Paper-Wrapped Wire

These colorful wires are easy to bend, are bright and versatile. Diameters vary from 1 mm to 5 mm; lengths vary from 45 cm to 60 cm. Green and brown wires are typically used for flower stems; yellow and red are often used for stamens and decorative touches around flower petals.

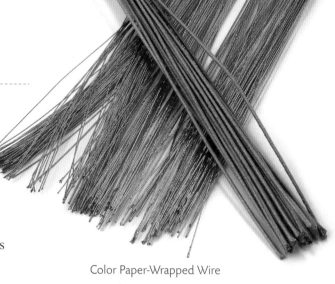

Color Paper-Wrapped Wire

## Color Tape

Use dark / light green and brown tape to connect flowers to branches, leaves, etc. The tape itself does not have adhesive; stretch the tape and use the friction between the tape plastic surfaces to secure.

Color Tape

## White Glue and Glue Stick

They can be used to adhere paper and various paper products. They are convenient to carry and easy to use.

White Glue and Glue Stick

## Acrylic Paints

Brilliant and rich colors; dries to create a waterproof layer in minutes, and does not fade easily.

## Hairspray

A thin layer on the surface of the finished project will help hold its shape for a longer period of time.

Acrylic Paints

Hairspray

Ribbon

Foam

### Ribbon
### (Stocking Flower Material)

They can be used as floral stamen.

### Foam

Use foam to fill in certain spaces in flower stamens to create a fuller effect.

### Ready-Made Stamens and Pistils

Sometimes you can find ready-made stamens and pistils. They come in numerous colors and varieties. Each measures about 6 cm in length and 0.3 cm in diameter. They can be used folded in half.

### Beads

They are used for stamens.

### Cotton, Wool and Nylon Threads

The threads can be used for flower stamens and pistils.

Ready-Made Stamens and Pistils

Beads

Cotton, Wool and Nylon Threads

# TOOLS

In the process of creating your art pieces, tools are often necessary, especially when handling accessories. Choose tools that you personally find easy to handle. This way, not only will you avoid injuries, it will dramatically increase your relaxed enjoyment and rate of success in creating the desired artwork.

X-Acto knife and scissors are for cutting and trimming; needle-nose pliers and diagonal pliers are for bending and shaping wires; pincers are for picking up small items; rulers are for measurements so works can be created precisely.

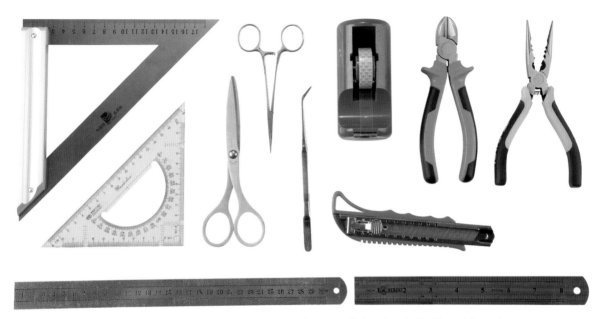

(From left to right) Ruler, scissors, needle-nose pliers, tape dispenser, X-Acto / art knife, diagonal liers, pincers.

*On facing page*
The plum blossom is an iconic traditional flower of China. In traditional Confucian view, the plum blossom's fight against winter frost symbolizes the character of a high noble gentleman, while its resilience against cold temperatures is a symbol of fortitude and bravery.

As a charm, the plum blossom also represents joy. It opens up to five petals, representing happiness, joy, longevity, success and peace, giving rise to the saying "blossom opens, five blessings." Also, magpies chirping joyously on plum blossom branches are taken as a good omen, often referred to as "good news of early spring, overwhelming joy above the brows." The Chinese characters for "magpie" contains a homophone of the Chinese word for "joy."

# SYMBOLS AND DIAGRAMS

The art of paper folding has enjoyed widespread popularity, thanks to a unified and complete system of symbols and diagrams. Once you understand the meaning of the symbols, you can replicate the beautiful works of art. The following section describes in detail all the symbols used in this book. With patience, learn and understand these different lines, arrows and folding methods, and you can create your desired art piece step-by-step.

## Lines

Lines represent the basic folds and creases.

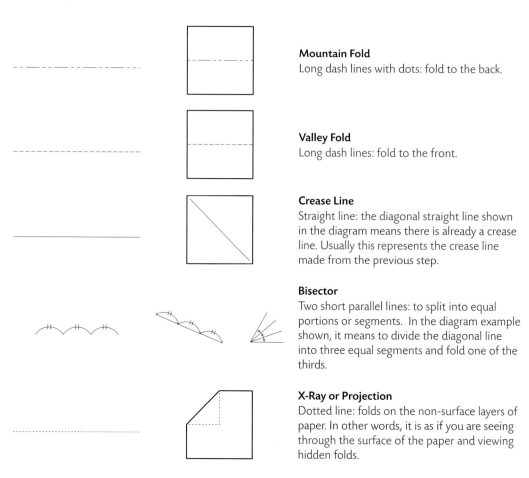

**Mountain Fold**
Long dash lines with dots: fold to the back.

**Valley Fold**
Long dash lines: fold to the front.

**Crease Line**
Straight line: the diagonal straight line shown in the diagram means there is already a crease line. Usually this represents the crease line made from the previous step.

**Bisector**
Two short parallel lines: to split into equal portions or segments. In the diagram example shown, it means to divide the diagonal line into three equal segments and fold one of the thirds.

**X-Ray or Projection**
Dotted line: folds on the non-surface layers of paper. In other words, it is as if you are seeing through the surface of the paper and viewing hidden folds.

## Arrows and Folds

Lines by themselves do not move. Arrows represent the direction of movement, allowing the paper to come alive.

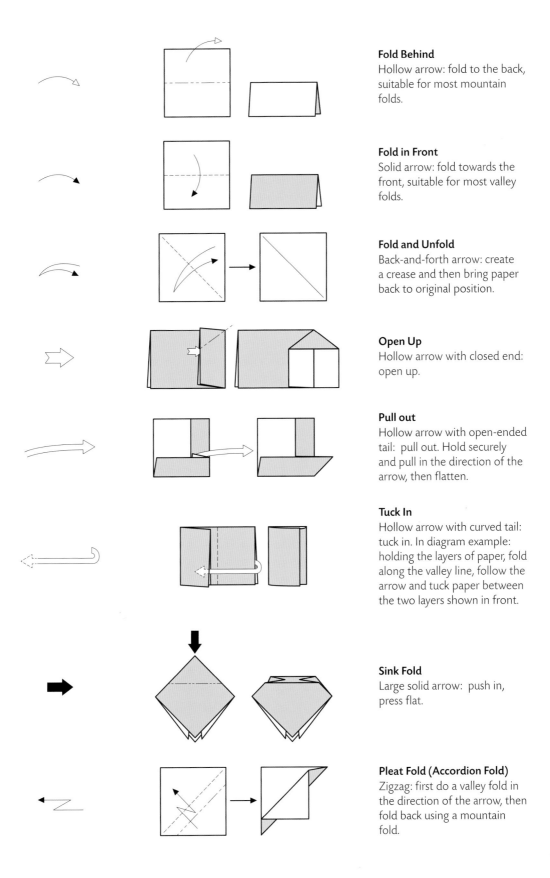

**Fold Behind**
Hollow arrow: fold to the back, suitable for most mountain folds.

**Fold in Front**
Solid arrow: fold towards the front, suitable for most valley folds.

**Fold and Unfold**
Back-and-forth arrow: create a crease and then bring paper back to original position.

**Open Up**
Hollow arrow with closed end: open up.

**Pull out**
Hollow arrow with open-ended tail: pull out. Hold securely and pull in the direction of the arrow, then flatten.

**Tuck In**
Hollow arrow with curved tail: tuck in. In diagram example: holding the layers of paper, fold along the valley line, follow the arrow and tuck paper between the two layers shown in front.

**Sink Fold**
Large solid arrow: push in, press flat.

**Pleat Fold (Accordion Fold)**
Zigzag: first do a valley fold in the direction of the arrow, then fold back using a mountain fold.

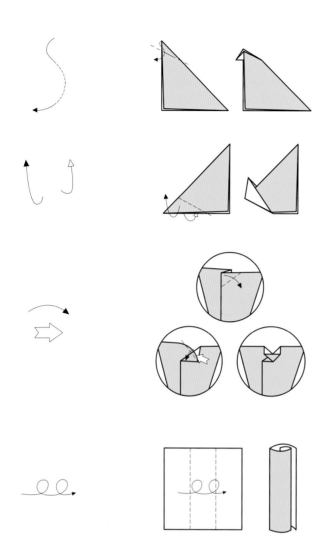

### Inside Reverse Fold
Arrow with curvy line: along a mountain fold, push inward to create a valley fold. Flatten the resulting two mountain folds.

### Outside Reverse Fold
Hollow arrow and solid arrow: along a mountain fold, push outward to create a valley fold. Flatten the resulting two valley folds.

### Pull Reverse Fold
Solid arrow and a hollow arrow with closed end: fold in the direction of the arrow along the valley line; spread and flip outward, flatten the bottom to create a small triangle. This fold is frequently used in folding flower petals.

### Roll
Solid arrow with two roundabouts: to measure a piece of paper into three equal sections without a ruler, use the roll method. Roll the paper, flatten slightly, and then visually gauge three equal widths. Makes 2 valley lines.

## Others

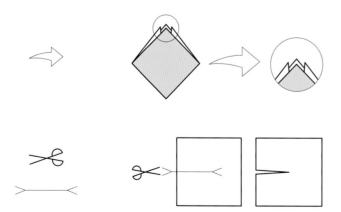

### Zoom In
Hollow arrow with sharp tail: zoom in. The combination of big and small circles illustrates the details of a small area. The image in the large circle (right) is the enlargement of the area in the small circle (left).

### Scissors and Cut Lines
A split end on a line represents a scissors cut line.

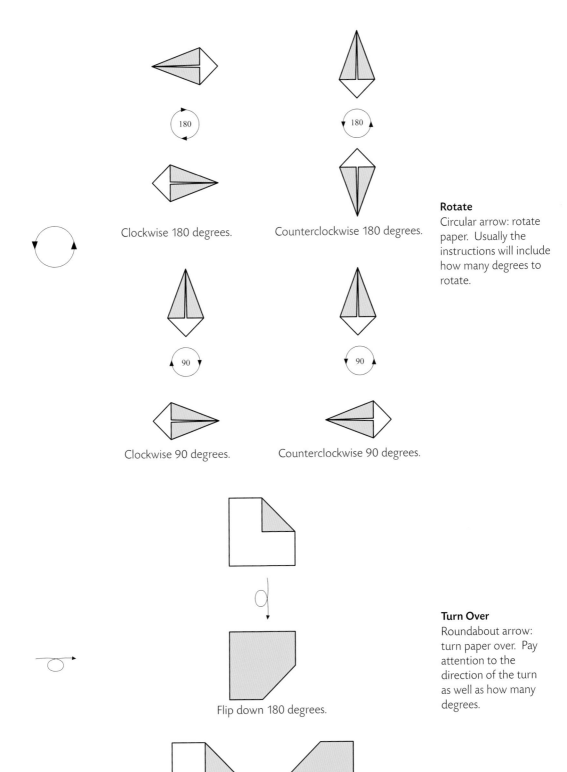

Clockwise 180 degrees.

Counterclockwise 180 degrees.

**Rotate**

Circular arrow: rotate paper. Usually the instructions will include how many degrees to rotate.

Clockwise 90 degrees.

Counterclockwise 90 degrees.

Flip down 180 degrees.

**Turn Over**

Roundabout arrow: turn paper over. Pay attention to the direction of the turn as well as how many degrees.

Flip to the right 180 degrees.

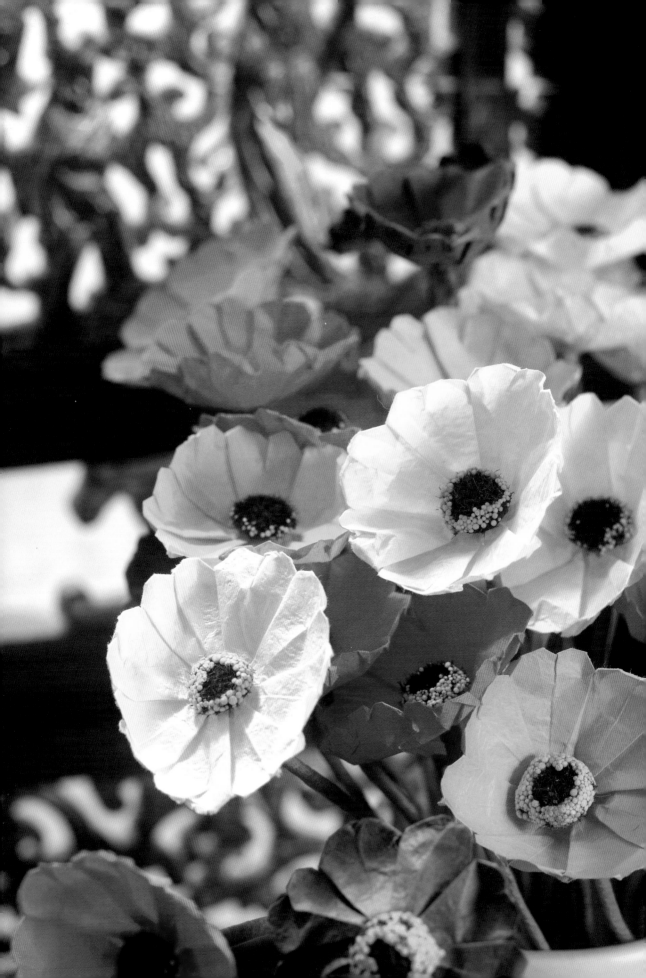

# Chapter 2

# BASIC SHAPES: REGULAR POLYGON

Once you have become familiar with the symbols and diagrams, this chapter introduces some basic techniques of paper folding.

Almost all paper folding begins with a square piece of paper. However, behind the art of paper folding, there are deep mathematical principles. In a variety of methods, a square can become an equilateral triangle, an equilateral 3-pointed star, and other basic shapes. These basic shapes in turn give birth to new, creative works.

Let's take the first step towards creating paper-folding artwork, and step into the wonderful world of paper folding.

## REGULAR TRIANGLE

1

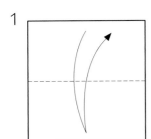

Create a valley fold as indicated by the arrow. Open back up to create a crease.

2

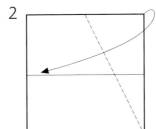

Fold along the valley line so that the upper right corner lines up with the crease.

3

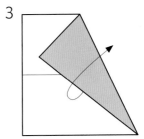

Open back up to leave a crease.

4

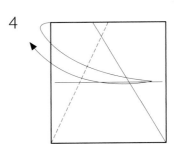

Fold along the valley line, so that the upper left corner lines up with the center crease. Open back up to leave a crease.

*On facing page*
Cinerarias, with their neat petals, grow in large, dense clusters. Because of their brilliant and dense bloom, Chinese people like to call them "Wealth Daisies." During the Spring Festival, multicolored cineraria bouquets are often used as ornamental displays. Not only do they liven the atmosphere of the Spring Festival, these flowers embody the meaning of "great luck, great riches and booming fortune."

5

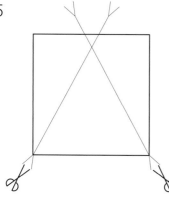

Cut along the two creases and discard the two side pieces.

6

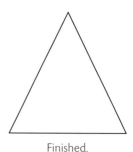

Finished.

## Using Tools

1. Use line AB as the length of one side of the triangle.
2. Using points A and B as centers, draw two arcs, each with radius of length AB. Where the two arcs meet, mark as point C. Connect lines AC and BC.
3. Cut along the three lines to create a triangle.

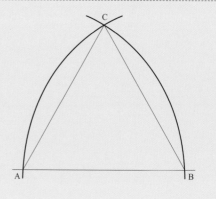

# THREE-POINTED STAR

1

Using the regular triangle as base, fold along the mountain and valley lines.

2

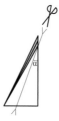

Cut along the cut lines. The angle α will be half the angle of one corner of the star.

3

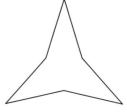

Open to finish.

# SQUARE

1

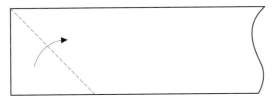

Fold along the valley line so that the left edge lines up with the top edge.

2

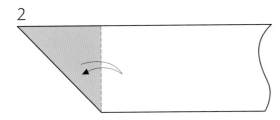

Fold along valley line to the right, then open back up to leave a crease.

3

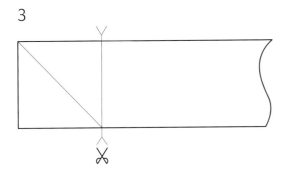

Cut along the vertical crease. Finished.

# FOUR-POINTED STAR

1

Using the square as base, fold along the mountain and valley lines as shown.

2

Flatten and then cut along the cut lines as indicated. The angle α will be half the angle of one corner of the star.

3

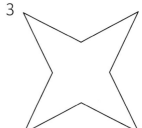

Open to finish.

# Pentagon

**1**

Create a valley fold, as indicated by the arrow.

**2**

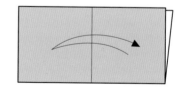

Fold in half again, creating a crease.

**3**

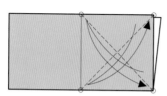

On the right half, take each corner and create valley fold creases along the diagonal.

**4**

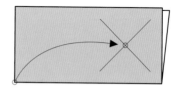

Bring the left bottom corner to the intersection of the two valley creases. Flatten.

**5**

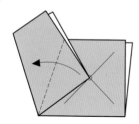

Make a valley fold as directed by the arrow.

**6**

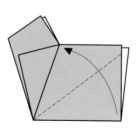

Make another valley fold as directed by the arrow.

**7**

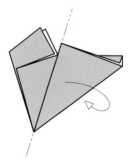

Make a mountain fold towards the back.

**8**

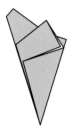

By now you should have this shape.

**9**

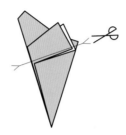

Cut along the cut line.

**10**

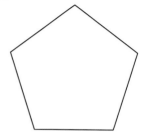

Finished: pentagon.

# FIVE-POINTED STAR

**1**

Follow instructions steps 1 through 8 for the pentagon. Then, draw cut lines as seen in the diagram above. Pay attention: the cut angle (between the cut line and the left side) should be greater than 90 degrees.

**2**

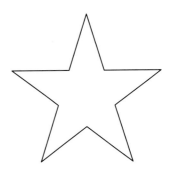

Five-pointed star after cutting as described. Pay attention: the larger the cut angle, the sharper the points of the star.

# HEXAGON

**1**

Using a long strip of paper, fold in half along the valley line.

**2**

Valley fold down in half then unfold, leaving a crease.

**3**

Do valley fold from top left corner towards the crease from step 2.

**4**

Do a mountain fold towards the back.

**5**

Fold towards the back using mountain fold.

**6**

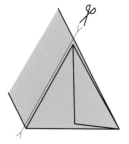

Cut along line to remove the rest of the long strip.

**7**

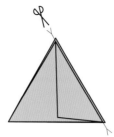

Cut away the extra triangle shape on the right.

**8**

Finished: hexagon.

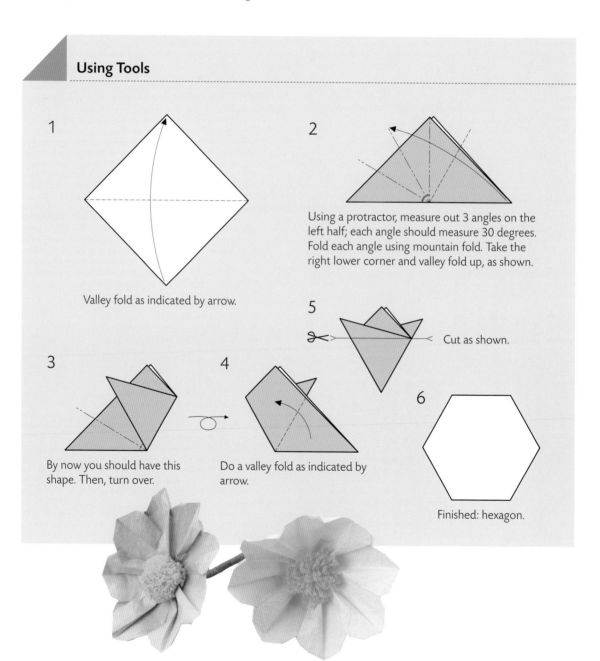

## Using Tools

**1**

Valley fold as indicated by arrow.

**2**

Using a protractor, measure out 3 angles on the left half; each angle should measure 30 degrees. Fold each angle using mountain fold. Take the right lower corner and valley fold up, as shown.

**5**

Cut as shown.

**3**

By now you should have this shape. Then, turn over.

**4**

Do a valley fold as indicated by arrow.

**6**

Finished: hexagon.

# Six-Pointed Star

### 1

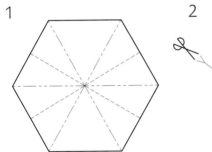

Follow instructions steps 1 through 8 for the hexagon. Valley fold as indicated.

### 2

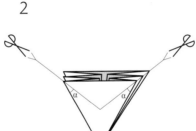

Cut along cut line, as shown.

### 3

Finished: six-pointed star. Pay attention: the larger the cut angle, the sharper the points of the star.

# Octagon

### 1

Fold along mountain and valley lines to create the shape shown in the next diagram.

### 2

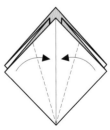

Fold toward the center along valley lines as indicated by arrows. Turn over and repeat.

### 3

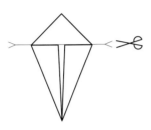

Cut away the triangle shape on top.

### 4

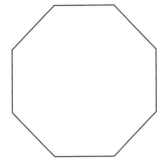

Open to finish.

## Folding Octagon with Another Method

**1**

Fold along mountain and valley lines to create the shape shown in the next step.

**2**

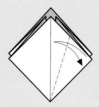

Fold toward the center along valley line and open to leave a crease.

**3**

Take one flap and open up along mountain and valley lines as indicated by arrow. Flatten to create shape as shown in the step 4.

**4**

Repeat for all flaps.

**5**

Cut away the extra triangle shapes on top.

**6**

Finished.

# Eight-Pointed Star

**1**

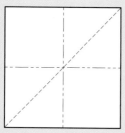

Follow instruction steps 1 through 3 of regular octagon (page 29) to get the shape as shown.

**2**

Fold along the center mountain line so that the piece is folded in half.

**3**

Cut along the cut line and remove the top portion. The angle α will be half the angle of one corner of the star.

**4**

Finished.

# Hexadecagon (16 Sides)

### 1

Fold along mountain and valley lines to create the shape shown in the next diagram.

### 2

Take the front flaps and fold along valley lines towards the center to create the shape shown in the next diagram.

### 3

Turn over and repeat the same.

### 4

Take the top flap from the left and fold along valley line towards the right as directed by the arrow.

### 5
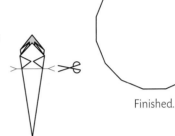

Fold toward the center along valley lines. Repeat for each face.

### 6

Cut along cut line. Open.

### 7

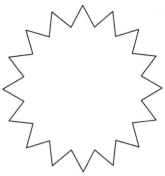

Finished.

# Sixteen-Pointed Star

### 1
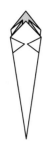

Follow instruction steps 1 through 6 for regular hexadecagon (see above) to create the shape shown above.

### 2
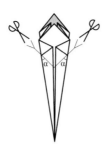

Cut along the two cut lines and remove the top portion. The angle α will be half the angle of one corner of the star.

### 3

Finished.

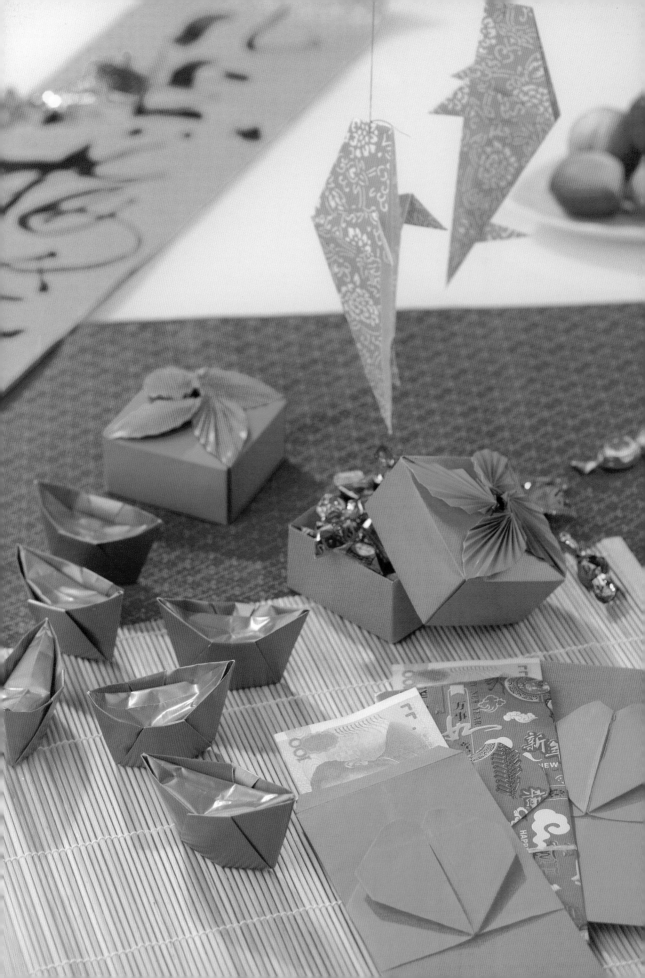

# Chapter 3

# HOLIDAYS AND WELL WISHES

Now that we have mastered basic techniques, let's move on to some case examples. Each example described in this chapter has deep Chinese cultural meaning.

## SPRING FESTIVAL

Spring Festival (or Chinese New Year) is the most ceremonious and most distinctive holiday festival in Chinese folk tradition. It is also the liveliest. There are many customs, all in the hopes of a new year of success.

On New Year's Eve, adults give "lucky money" in red envelopes to children. This custom originated from a legend: Long ago there was a little monster and on the night of New Year's Eve, this monster would visit children while they slept and touch their heads three times. Children would be scared sick or, even worse, become fools. So in those days, people wrapped eight coins in red paper, and placed them next to the children's pillows. The little monster was afraid of the color red, so he stopped visiting. "Lucky money" continued to this day as a symbol of adults' blessings to young children.

During New Year's Eve, dinner must include fish. In China, fish is a symbol of plentiful bounty and luck. This is because the word for "fish" (鱼, *yu*) and "overflow" (余, *yu*) are homophones, signifying an overflow of wealth.

The gold ingot was the currency used in ancient China. Even though it has stepped off the stage of history, the shape is still deep in people's hearts and has come to symbolize "Inviting Wealth, Advancing Treasures."

During the New Year celebration, one important custom is to invite friends and family to the home and be a good host. The capable host would present sweets in beautiful boxes, signifying a new year of sweet life and joy. The candy box is both practical and decorative, and may even bring good luck.

*On facing page*
Brilliantly colored red envelope, candy box, gold ingot and fish bring the Spring Festival to life.

# Red Envelope for Lucky Money

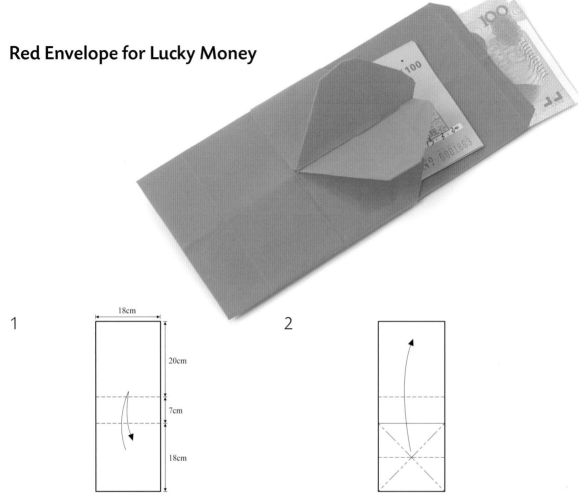

**1**

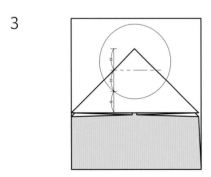

Begin with a rectangular sheet of red paper, measuring 45 x 18 cm. Fold valley folds according to the measurements in the diagram, and then unfold. The paper should now have two creases. The area below the bottom crease is a square measuring 18 x 18 cm.

**2**

In the square area below the bottom crease, do mountain and valley folds as indicated in diagram. Then, fold up along the top crease created in step 1, as indicated by the arrow in the diagram.

**4**

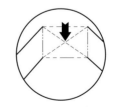

Fold inward and press, as indicated by lines and arrows in this diagram.

**3**

In the triangle created, fold the top third (1/3) of the triangle towards the back along the mountain line.

**5**

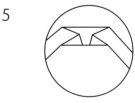

Flatten.

**6**

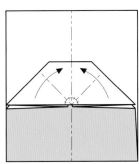

Fold towards the front along valley lines.

**7**

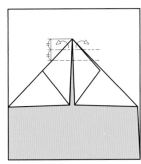

Fold back along mountain lines. The mountain line should be placed about halfway down the small triangle in the top area.

**8**

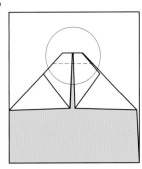

Result so far. The dash line inside the circle is only used as a guide to indicate the small triangle area on top. Do not fold along this line.

**9**

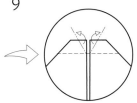

Fold towards the back along two slanted mountain lines, as shown.

**10**

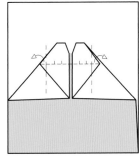

Using the guide line, measure a section about 1/4 of the way and draw a mountain line. Fold towards the back along mountain lines.

**11**

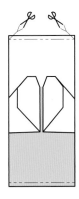

First, fold towards the back along the middle mountain line. Then, for each side, fold towards the back along the other two mountain lines, as shown.

### Making Envelop with Tight Seal

For an envelope with a tighter seal, take each mountain line from the two sides and move it 5 mm towards the middle.

**12**

Measure a mountain line approximately 1 cm from the bottom edge, and fold towards the back. Seal with glue; this is the bottom of the envelope. Measure another mountain line approximately 1 cm from the top, and fold towards the back. Cut a corner, as shown. Fold and use as the envelope seal.

# Fish

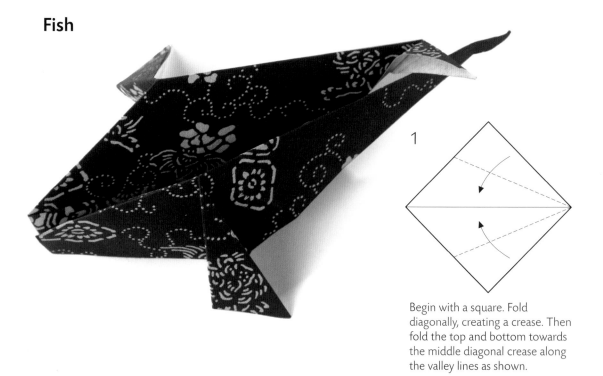

**1**

Begin with a square. Fold diagonally, creating a crease. Then fold the top and bottom towards the middle diagonal crease along the valley lines as shown.

**2**

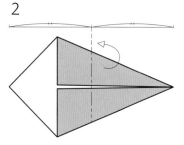

Measuring from left to right, split into two equal halves. Fold towards the back along mountain line.

**3**

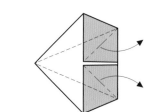

Do mountain and valley folds towards the right as indicated by arrows. Flatten.

**4**

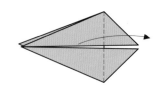

Take the top flap and do a valley fold towards the front, as shown by arrow.

**5**

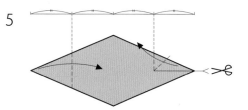

Measure out 4 sections evenly from left to right. Cut as indicated by cut line in the quarter section on the right end. Do a valley fold towards the front as shown. On the left end, do a valley fold towards the front.

**6**

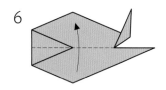

Do a valley fold towards the front.

**7**

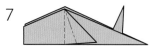

Do mountain and valley folds as shown. Do the same on the other side.

**8**

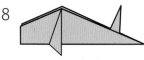

Finished.

# Gold Ingot

**1**

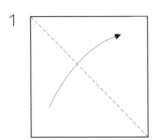

Begin with a square sheet of paper and fold diagonally along valley line.

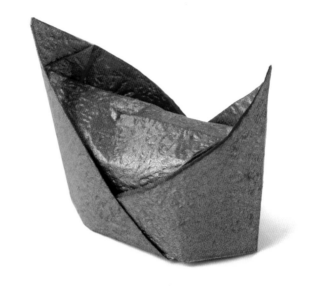

**2**

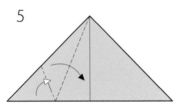

Take the triangle's left edge and fold towards the middle crease, using a valley fold towards the front.

**3**

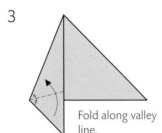

Fold along valley line.

**4**

Result so far.

**5**

Open in the direction of the arrows. Spread along mountain and valley lines. Flatten.

**6**

Take the corner of the square section and fold towards the back along mountain line, as shown by arrow.

**7**

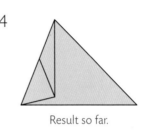

Fold towards the back along mountain line.

**8**

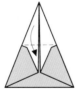

Repeat on the right side. Once you have the triangle shape as shown, take the front flap and fold towards the front, and take the back flap and fold towards the back.

**9**

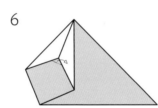

Take the small triangle areas that go past the bottom edge, and tuck in along mountain lines. This will prevent loosening of the internal structure.

**10**

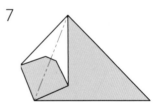

Spread open the bottom section. Press down on the top section. Mold into shape. Finished.

# Candy Box

## Box Base

**1**

Fold along each of the two valley lines towards the front as shown; then open back up, leaving two creases.

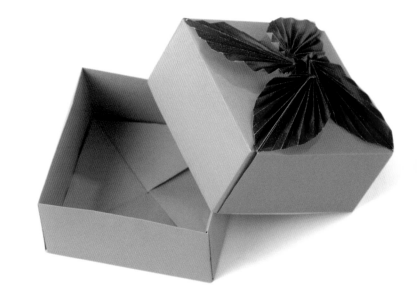

**2**

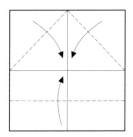

Fold along the three valley lines, as shown, towards the front.

**3**

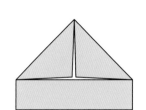

You should have this shape so far.

**4**

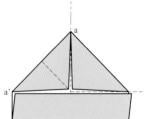

Fold point a towards point a' using the mountain and valley lines shown in the diagram.

**5**

Fold point a towards point a', along the valley line shown (point a' is the midpoint along this edge).

**6**

Mold into shape. Then, repeat steps 1 through 5 three times to create three additional "Corners."

**7**

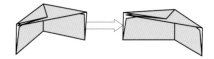

Slide one side of one "Corner" into the side of another "Corner" as shown in the diagram. Repeat with all four "Corners" to complete the candy dish base.

## Box Lid

**1**

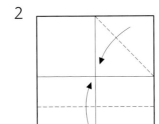

Fold along each of the two valley lines towards the front as shown, then open back up, leaving two creases.

**2**

Fold along the two valley lines, towards the front, as shown.

**3**

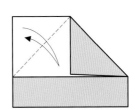

Fold along the valley line, and then open back up, leaving a crease.

**4**

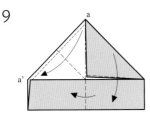

In the upper left triangle created from step 3, fold into 8, 12, or 16 diagonal creases. The diagonal creases will appear on the decorative leaves on the cover; so the more creases you fold, the denser the leaf pattern. Flip to the right 180 degrees.

**5**

Result so far.

**6**

Fold into segments, as indicated by mountain and valley lines shown.

**7**

You should have this shape at this point. Flip 180 degrees to the left.

**8**

You should have this shape so far.

**9**

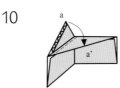

Fold along the mountain and valley lines as indicated by arrows. Fold point a towards point a'.

**10**

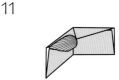

Fold point a towards point a', as indicated by valley line and arrow (point a' is the midpoint along this edge).

**11**

The leaf folds will fan out naturally. Mold into leaf shape. Repeat the above steps three more times to create a total of 4 sections.

**12**

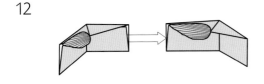

Slide one side of one section into the side of another section, as shown in the diagram. Repeat with all four sections to complete the candy dish lid.

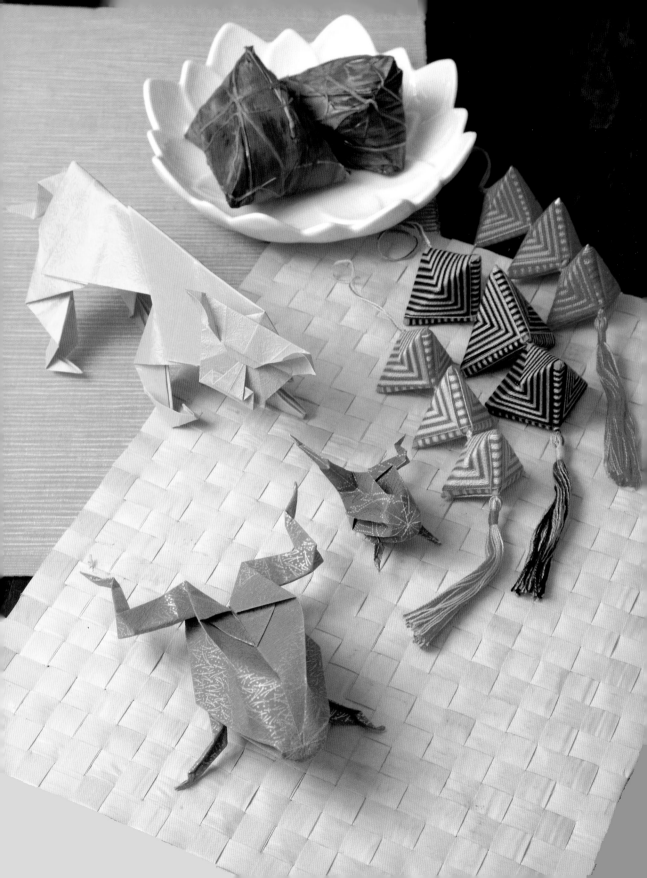

# DRAGON BOAT FESTIVAL

Dragon Boat Festival falls on the 5th day of the 5th month on the lunar calendar. Chinese people have been celebrating this festival for over 2,000 years. There have been many claims as to the origin of this festival, but the most widespread story commemorates a man named Qu Yuan.

On the 5th day of the 5th lunar month of 278 B.C., the patriotic poet and Grand Master Qu Yuan heard the news that the Qin army had defeated the Chu capital. Grief stricken, he committed ritual suicide by holding a large rock and throwing himself into the Miluo River as a martyr for the country. People along the river paddled boats to attempt a rescue, while throwing *zongzi* rice dumplings into the river to distract fish from eating his body. As Qu Yuan's influence spread, the festival began to spread as well. Now, the Dragon Boat Festival is officially on the UNESCO Intangible Cultural Heritage List. This is the origin of the custom of eating *zongzi* and rowing dragon boats.

In addition, around the season of the Dragon Boat Festival, weather tends to be damp, and people get sick easily. Folks practice the customs of plucking papyrus leaves, drinking yellow rice wine, and hanging spice sachets. On the morning of the festival, the first order of business is to wrap multicolor silk threads around the wrists of children. Young girls carefully make *zongzi*-shaped sachets filled with spices and herbs that ward off toxins; these sachets are wrapped with multicolor silk threads. In many parts of China, parents place tiger heads and tiger shoes on their children. Because the tiger is the king of beasts, its fierce powerful energy can ward off evil spirits and protect the children. Thus, the Dragon Boat Festival is a folk custom that wards off sickness and brings blessings of health.

The Dragon Boat Festival, on the 5th day of the 5th month, is also the time when the "five poisons" appear: snake, scorpion, centipede, lizard, and toad. A variety of methods are devised to avoid them. People place pictures of the "five poisons" around the home, and wear clothing embroidered with the "five poisons" all in an effort to ward off evil and illness.

The customs of Dragon Boat Festival changed after arriving in Japan. In the Japanese language, the words for "calamus" and "warrior" are homonyms, and the festival gradually turned into Boys' Day. The day is also Children's Day in Japan. It is celebrated on the 5th day of the 5th month on the western calendar.

*On facing page*
During Dragon Boat Festival, fold bundles of *zongzi*, tigers and toads to match the theme of the holiday.

# Tiger

## Front Half

**1**

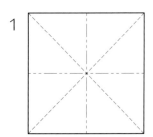

Fold along mountain and valley lines.

**2**

You should have this shape.

**3**

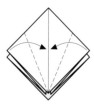

Fold along valley lines towards the middle crease as indicated by arrows.

**4**

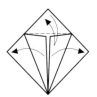

Take the top triangle and fold down along valley line, then open back up to leave a crease. Take the bottom two flaps and open as indicated by arrows. Repeat on the other side.

**5**

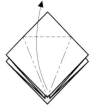

Take the bottom tip and fold open towards the top, along mountain and valley lines. Repeat on the other side. You should have the shape shown in the next step.

**6**

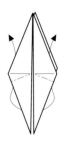

Inside reverse fold along mountain lines.

**7**

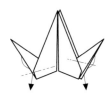

Inside reverse fold along mountain lines. You should have the shape shown in the next diagram.

**8**

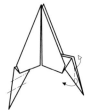

On the right side, do an outside reverse fold along valley line. On the left side, do inside reverse folds—once on top (along mountain line) and once on bottom (along valley line).

**9**

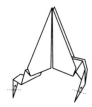

Do inside reverse folds along mountain lines as indicated by arrows.

**10**

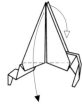

Take the top triangle and fold down along valley line as indicated by arrow. Repeat on the other side.

**11**

Fold along valley line as indicated by arrow. Rotate 90 degrees counterclockwise. You should have the shape shown in the next step.

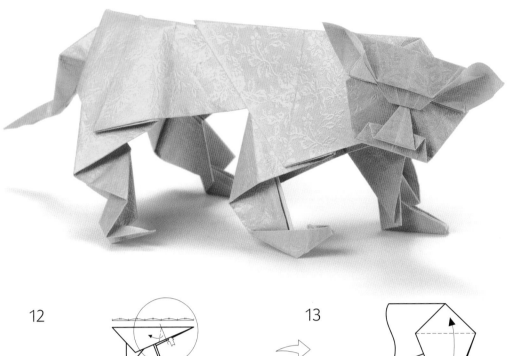

**12**

Split the top edge into 5 equal segments. From the second segment, open up as indicated by the hollow arrow and then flatten along mountain and valley lines. You should have the shape shown in the next step. Note that the longer the segment, the bigger the tiger head.

**13**

Fold front flap along valley line towards the top as indicated by arrow.

**14**

Cut along lines ab and a'b' on the top layer, then open up. In the bottom triangle area, fold along mountain and valley lines. You should have the shape shown in the next step.

**15**

Fold along mountain and valley lines.

**16**

Spread open the two side tips, then fold along valley lines.

**17**

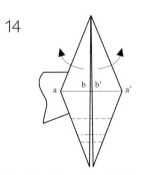

Tiger's head is finished.

**18**

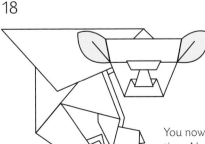

You now have the front half of the tiger. Next, we will create the hind half of the tiger's body.

## Hind Half

**19**

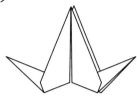

Repeat steps 1 through 6. You should have this shape.

**20**

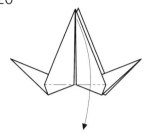

Take the triangle from the front flap and fold down along valley line.

**21**

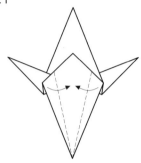

For the front flap: fold along valley lines towards the center.

**22**

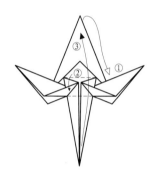

On the back side, flip down as indicated by arrow 1. On the top, fold the triangle downward along valley line as indicated by arrow 2. On the bottom, fold triangle upward along valley line as indicated by arrow 3. You should have the shape as shown in the next diagram.

**23**

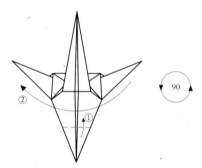

On the back, fold upward along valley line as indicated by arrow 1. Then fold the side to the left as indicated by arrow 2. Turn 90 degrees counterclockwise.

**24**

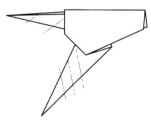

The top triangle is the tiger's tail; fold along mountain and valley lines. The bottom two triangles are the hind legs of the tiger (the picture shows just one of the legs). For each leg: first fold along the top mountain line; then do an inside reverse fold along the middle mountain line; finally do an inside reverse fold along the bottom mountain line. Repeat on the other leg.

**25**

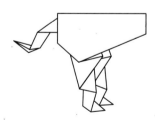

Tiger hind half finished. Insert the hind half into the front half to finish. You may use glue to secure the two halves together.

# *Zongzi* Bundle

1

Start with a long strip of paper. Draw valley lines as shown above. Fold along valley lines, then open back up, leaving creases. A longer strip means more squares, which creates a sturdier *zongzi*.

2

Overlap edge a with edge a'; b with b'; c with c'; d with d'. You should now have a hexahedral (see diagram in the next step). Continue to wrap the strip around the outside of the hexahedral. When you reach the end of the strip, tuck the shaded end into an edge opening and secure with glue.

3

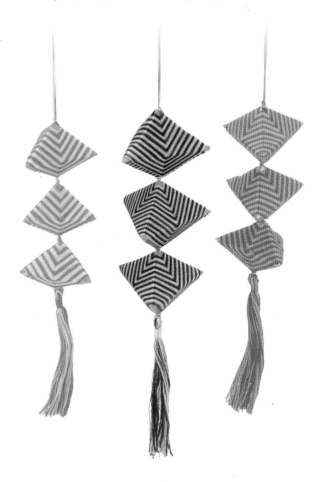

*Zongzi* finished. Use different colors to make 3–4 *zongzi*, and then string them together to create a multicolor bundle. You can also use thicker string to wrap the *zongzi*, then add fringes to the bottom. In this way, you have just created richly colored and uniquely Chinese-style *zongzi* bundles.

# Toad

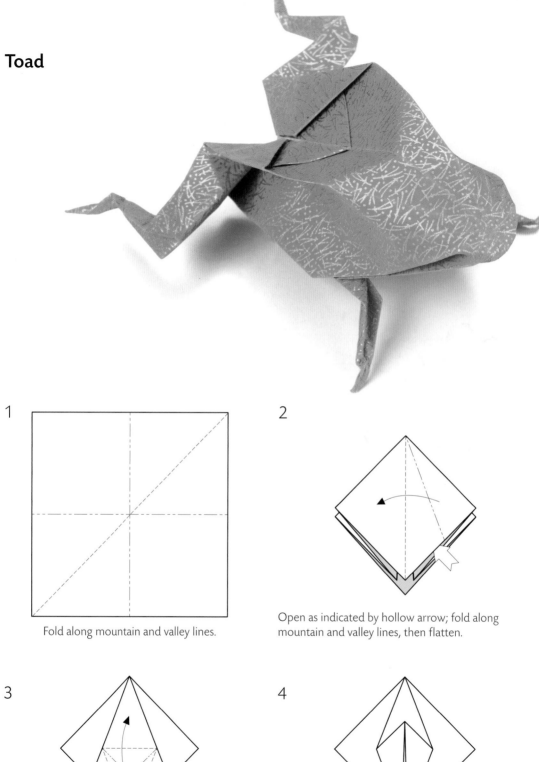

**1**

Fold along mountain and valley lines.

**2**

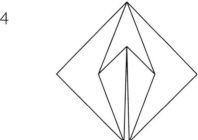

Open as indicated by hollow arrow; fold along mountain and valley lines, then flatten.

**3**

Fold up along mountain and valley lines as indicated by arrows. You should have the shape shown in the next step.

**4**

Repeat the same steps on all sides. You should have the shape shown in the next step.

**5**

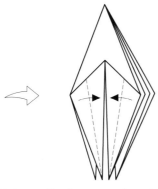

Fold along valley lines towards center. Repeat on all sides.

**6**

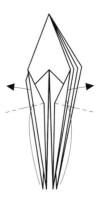

Inside reverse fold the front flap along mountain line.

**7**

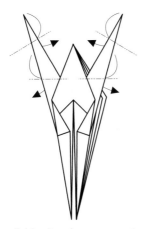

Inside reverse fold twice along mountain lines. You should have the shape shown in the next step. These are the front legs of the toad.

**8**

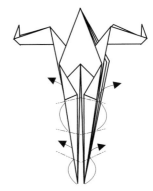

Turn over. Inside reverse fold three times, as indicated by mountain lines in the diagram. These are the hind legs of the toad.

**9**

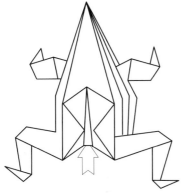

Blow into the hole on the bottom to inflate the toad. Mold into shape to finish.

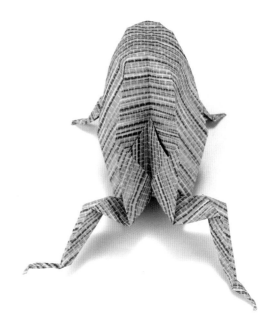

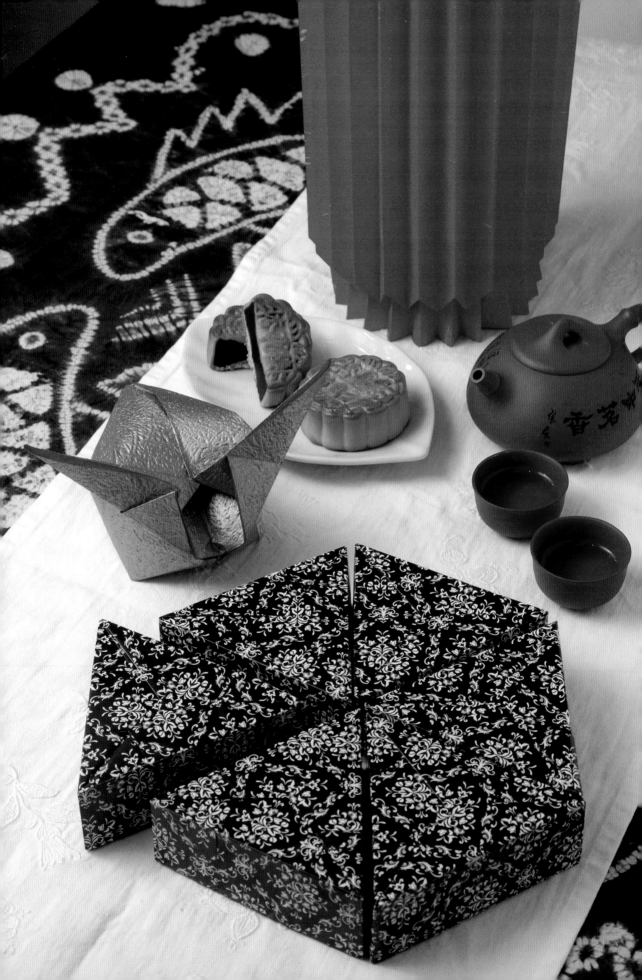

# MID-AUTUMN FESTIVAL

During the autumn season, on the 15th day of the 8th month in the lunar calendar, Chinese people celebrate the Mid-Autumn Festival. Mid-Autumn Festival has been celebrated since the Tang Dynasty; customs include banquets, offerings to the moon, moon viewings, moon cakes, lanterns and many more.

Mid-Autumn Festival is closely woven with the ancient legend of "Chang'e Chasing the Moon." A woman named Chang'e, having ingested an immortality elixir acquired by her husband Houyi from the gods, flew to the moon. Houyi, missing his wife, would make a round cake during the full moon and place it in the courtyard while calling out his wife's name. Sure enough, Chang'e appears, and husband and wife are reunited. In the same legend, a rabbit in the palace of the moon spends day and night searching for more immortality elixir for Chang'e. The rabbit has become an auspicious symbol that wards off illnesses and misfortunes.

During the festival, families celebrate with moon cakes. The cake has to be cut into the same number of pieces as there are people, so everyone gets a piece. If a family member had not come home for the festival, the parent has to save a piece for when that person visits; this symbolizes family togetherness with the completion of a full circle (cake). For this practice, Mid-Autumn Festival is also called the Reunion Festival. The moon cake box illustrated in this book consists of six triangular pieces that form a full round cake. Each triangular piece is a slice of the moon cake, and together they unite to form a whole.

In Guangdong, China and other parts of Southeast Asia, there is another Mid-Autumn Festival custom of carrying a lantern. Each home would display numerous lanterns—the more variety, the more auspicious. At night, candles are placed in the lanterns, and the lanterns are attached to bamboo poles and hung on balconies, rooftops and trees to represent blessings for the household. Mid-Autumn Festival lanterns come in all shapes and sizes; common shapes include fish, animals and fruits. By evening, towns are lit up with lanterns like a starry night, echoing the bright full moon in the sky.

On an autumn night, with the backdrop of the full moon and lanterns of blessings, families gather to enjoy each other's company while admiring the bright moon and eating moon cake. This is the essence of the joy of the festival.

*On facing page*
During Mid-Autumn Festival, eat moon cake and hang lanterns. Remember to recite the legend of Chang'e Chasing the Moon.

# Moon Cake Box

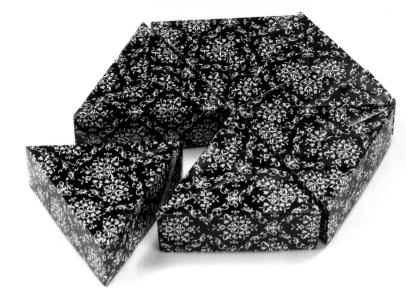

**1**

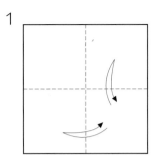

Fold along valley lines then open to leave creases.

**2**

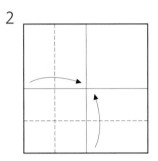

First, fold up along horizontal valley line. Then fold to the right along vertical valley line.

**5**

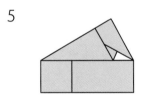

You should have this shape at this point. Open back up.

**8**

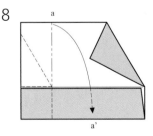

Fold along mountain and valley lines, so that point a touches point a' on the bottom edge.

**3**

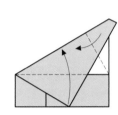

Fold along valley line as indicated by arrow, so corner A meets the bottom edge. Note: Point B and point C lie along the same line.

**6**

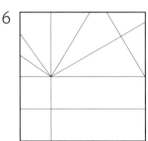

You should see all these creases as shown in the diagram.

**9**

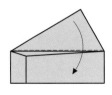

**4**

Fold the upper right corner diagonally down and to the left. Then fold the bottom corner upward along the horizontal valley line.

**7**

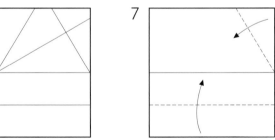

Fold along valley lines as shown by arrows.

Fold the top triangle down 90 degrees along valley line. Insert the front flap into the rear square. This completes one component. Repeat the above steps to create two more components; insert into each other to create the box lid. Refer to page 38 for similar instructions for the candy box. Using paper of a slightly smaller size, repeat the above steps to create three more components. Insert into each other to create the box bottom.

# Lantern

## 1

Take a rectangular piece of paper and split into 32 equal sections. Fold along mountain and valley lines, then open back up, leaving creases. Note that changing the number of folds will change the pleating effect on the lantern.

## 2

With a ruler, draw valley and mountain lines as indicated. Note the pits of the valley lines from the top portion should line up with the peaks of the mountain lines from the bottom portion. Pay attention to the red lines.

## 3

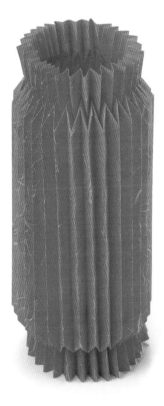

Using the same method, draw valley and mountain lines on the bottom portion. Then fold along mountain and valley lines. Finally, use white glue to secure the two edges to form a cylinder. Finished.

This lantern can also be used as a lampshade to add a touch of Chinese style to your home.

# Rabbit

1

Fold along mountain and valley lines as shown.

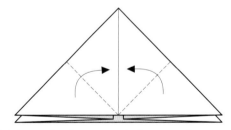

2

Fold along valley lines towards the center line as indicated by arrows.

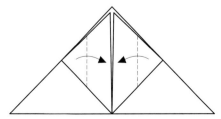

3

Fold along valley lines towards the center line.

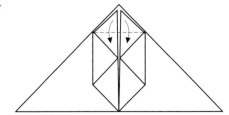

4

Fold down along valley line as indicated by arrows.

5

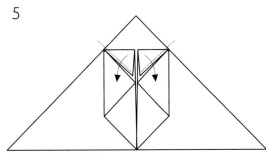

Do inside reverse folds along valley lines as indicated by arrows.

6

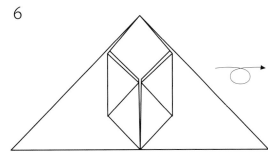

You should have this shape. Turn over.

7

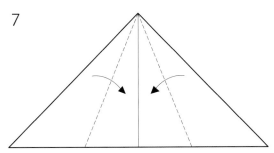

Fold along valley lines towards the center line.

8

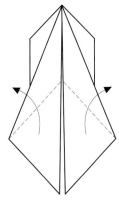

Fold along valley lines as indicated by arrows.

9

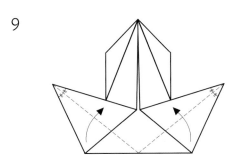

Measure half the angle on the side tips. Fold along valley lines as indicated by arrows.

10

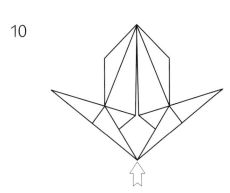

Inflate the rabbit by blowing air through the small opening. Finished.

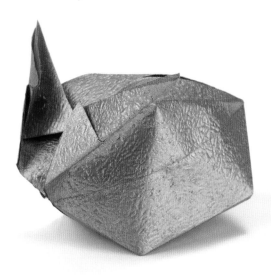

# Jiangnan Water Village

Since ancient times, Jiangnan Water Village, in the lower reaches of the Yangtze River, has been known as the home village of rice. It is full of historical and cultural heritage. Jiangnan Water Village is also well known for its elegant architectural style and rustic folk customs. The town of Zhouzhuang, known as "The Venice of the East," is a representative of Jiangnan Water Village.

In a water village, water is the source of life. Awning boats are the unique transportation vehicle of Jiangnan Water Village. The hulls are narrow, and the low-arched awnings are usually made from woven bamboo. Painted with dark oils on top, the awnings provide shade as well as shelter from the rain. They are like the elves of the calm water channels, watching as people and the world go by.

The sunset reflection of the pagoda in Jiangnan Water Village also makes for impressive scenery. The pagoda is architecturally full of traditional eastern style.

The lotus flower is one of the iconic flowers of China; they come in many colors, like red and pink. Its fragrance fills the air. The lotus flower greets the sun without fear. They grow from mud but are not tainted. Since the words for lotus (荷, *he*), harmony (和, *he*) and togetherness (合, *he*) are homophones, lotus flowers are often used to symbolize peace and harmony.

In the summer, the awning boats sway on the meandering rivers; together with the blossoming lotus flowers, they form the unique style and character of the water village.

## Awning Boat

1

Begin with a square. Fold and open to create creases, as indicated by diagram.

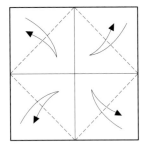

2

Fold along each of the four vally lines, then open back up, creating creases.

*On facing page*
Rivers, awning boats, lotus flowers and pagoda form the picture of the Jiangnan water village. Fold it all with paper for a distinct charm.

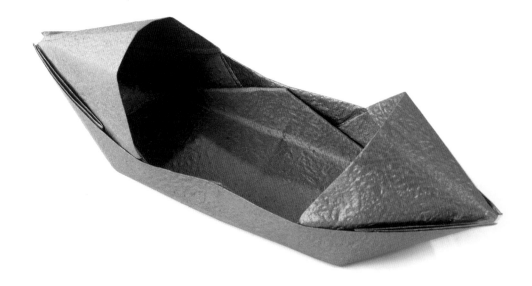

**3**

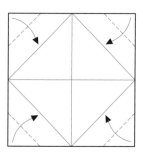

Fold along valley lines towards the front, as indicated by arrows.

**4**

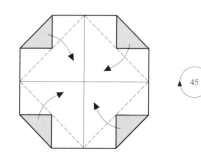

Fold along valley lines towards the front, as indicated by arrows. For easier handling: after folding each corner, turn the paper 90 degrees clockwise, then work on the next corner.

**5**

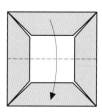

Fold along valley line, down and towards the front.

**6**

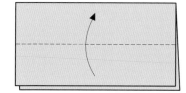

Fold along valley line, up and towards the front. Repeat with the flap on the other side.

**7**

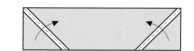

Fold along the valley lines towards the front.

**8**

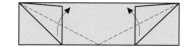

Fold along the valley lines towards the front.

9

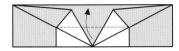

Fold along valley line up and towards the front.

10

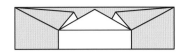

You should see this result so far. Flip over, and repeat steps 7, 8, and 9 on the other side.

11

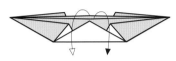

You should have this shape by now. Turn from top towards the bottom, as indicated by arrows.

12

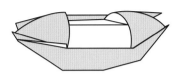

Spread open the two triangles on the ends. Mold into shape to finish.

# Lotus Flower

## Leaf

1

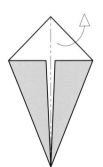

Refer to page 29 for the instructions of octagon. Follow instructions steps 1 through 3 to shown above. Make mountain fold towards the back.

2

Cut along cut line (as shown), then open.

3

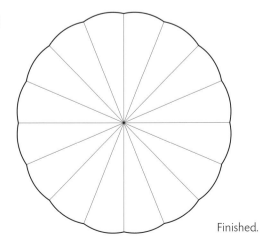

Finished.

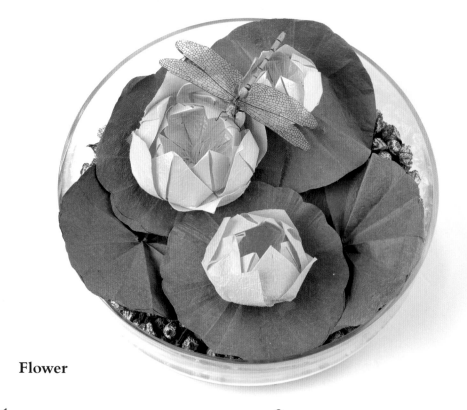

## Flower

**1**

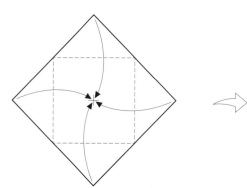

Fold each corner to the center using valley folds.

**2**

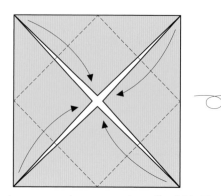

Fold each corner to the center using valley folds. Turn over.

**3**

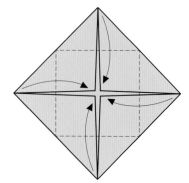

You would have this shape by now.

**4**

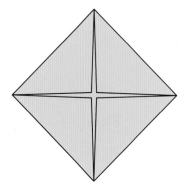

Fold each corner to the center using valley folds.

**5**

So far you would see this shape.

**6**

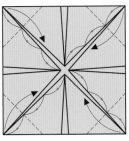

See four small squares. In each small square, split the diagonal into three segments. Fold in each corner using valley folds, as shown.

**7**

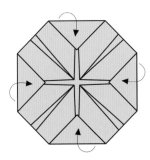

After the last step, the result should look like this. Pinch one of the corner flaps.

**8**

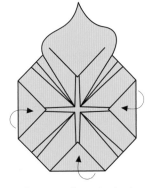

Pull and flip each corner from the back, as shown by arrows.

**9**

With the remaining four corners on the back side, pull out as indicated by the arrows.

**10**

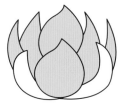

Finished. Using thin metal wire, form a hook on the end and secure the pistil of the lotus flower. Secure with nylon string. Wrap wire with green tape and insert lotus flower and leaf. Because lotus flowers float on the surface of water, the wire used in assembling the flower can be cut according to however you choose to display it. Finally, design the placement of the flower and the leaf, and secure in place.

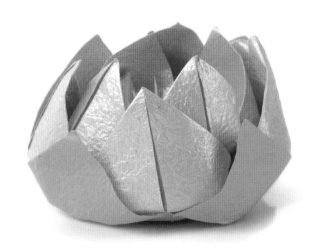

Now, using similar method but with just a few tweaks, we will show you how to make a spherical lotus lantern. This makes for a beautiful display piece!

1

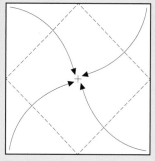

Fold along valley lines towards the center point as indicated by arrows.

2

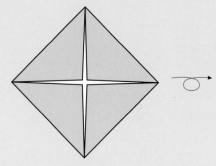

You should have this shape at this point. Turn over.

3

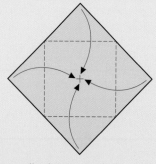

Fold along valley lines towards the center point as indicated by arrows.

4

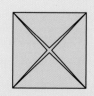

You should have this shape at this point. Turn over again.

5

Fold along valley lines towards the center point as indicated by arrows.

6

You should have this shape at this point. Turn over again.

**7**

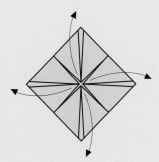

Outside reverse fold each of the four petals as indicated by arrows. Mold into shape. This is the large lotus for the bottom.

**8**

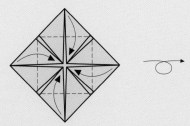

Using paper of the exact same size, repeat steps 1 through 6 to get this shape as shown in diagram. Fold along valley lines towards the center as indicated by arrows. Turn over.

**9**

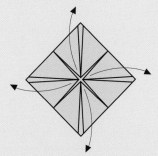

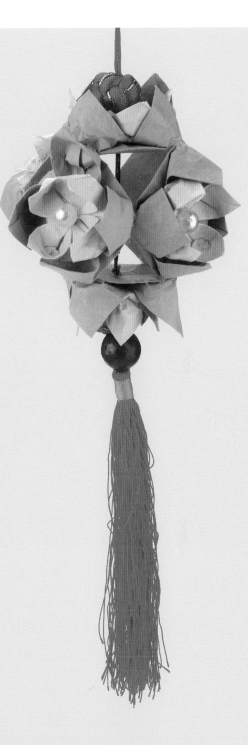

Outside reverse fold each of the four petals as indicated by arrows. Mold into shape. This is the small lotus. Apply glue to the bottom of the small lotus and place into large lotus to adhere. Repeat the above steps to create five large-small combo lotus lamps. Adhere the six lotus lamps together to create a spherical lotus lantern. For an even better effect, add fringes to the bottom of the lantern, or add embellishments to the center of each small lotus.

# Pagoda

1

Fold along mountain and valley lines.

2

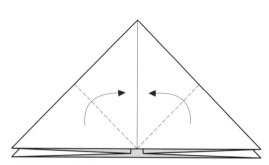

Fold along valley lines as indicated by arrows. Repeat on the reverse side.

3

Open flap as indicated by arrow and then flatten along mountain lines. Repeat on the left side. Turn over and repeat on the reverse side.

4

Fold along valley lines as indicated by arrows. Repeat on reverse side.

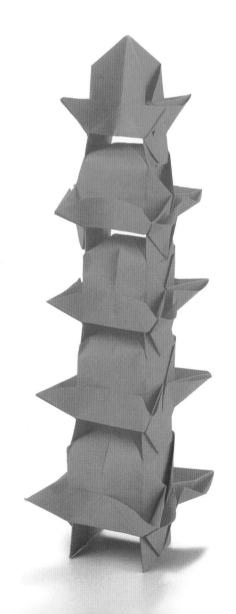

5

Fold along valley line as indicated by arrow. Repeat on reverse side. You should have the shape as shown in the next step.

6

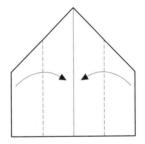

Fold along valley lines towards the center line as indicated by arrows. Repeat on reverse side.

7

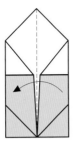

Fold along valley line as indicated by arrow. Repeat on reverse side.

8

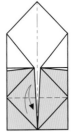

Fold the bottom small triangle up along valley line and then open back up to leave a crease. Repeat on reverse side.

9

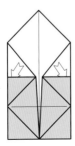

Open up as indicated by hollow arrows. Flatten along creases.

10

One section of the pagoda is finished.

11

Repeat four more times. Insert each section's top into the next section's bottom. The more sections you create, the taller the pagoda.

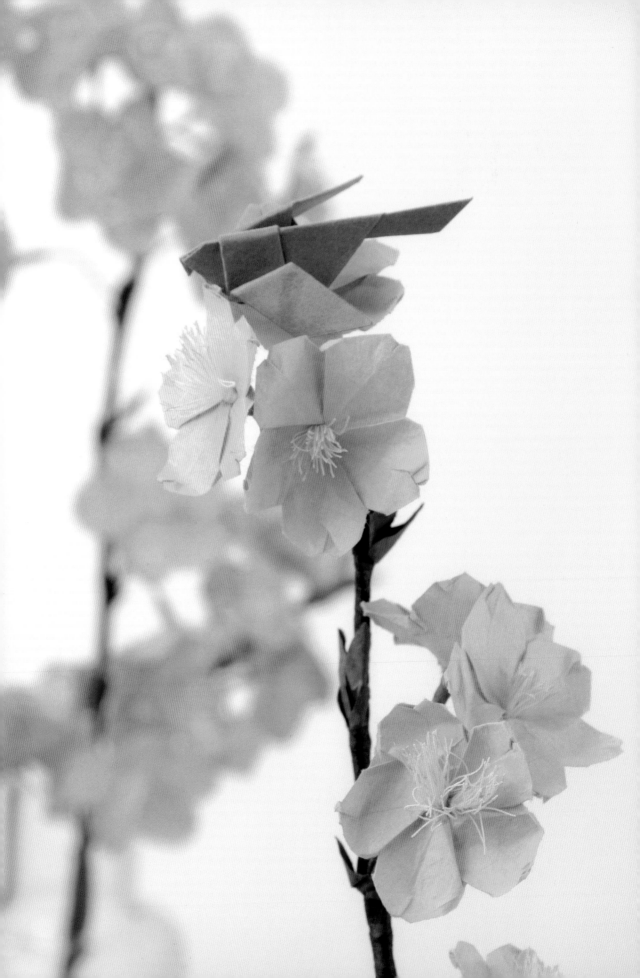

# OVERFLOWING JOY

In ancient times, the magpie represented joy. During the Tang Dynasty, people took the song of the magpie as an auspicious omen. At the time, many mirrors, tapestries and ceramics were decorated with patterns of the magpie.

At the same time, the word for plum blossom is a homophone of the word for brow. When a magpie lands on a plum blossom branch, the image is described as "joy upon the eyebrows," which has come to mean the fulfillment of wishes and a long series of luck.

For the plum blossom, you can refer to the Flower Assembly on page 142.

## Magpie

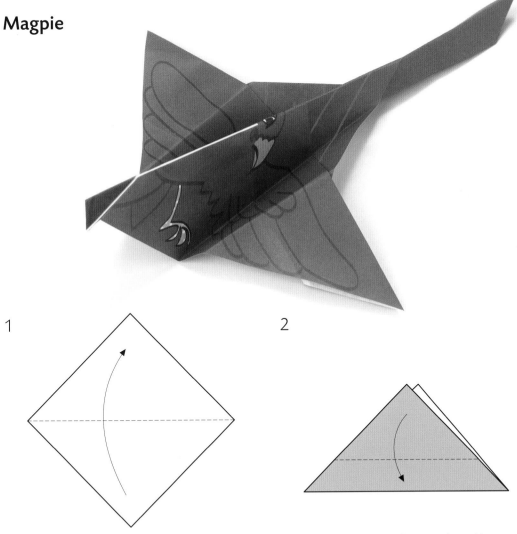

1

Fold up along valley line as indicated by arrow.

2

Fold down along valley line as indicated by arrow.

*On facing page*
A magpie sitting on a blooming plum blossom is an auspicious sign of joy.

**3**

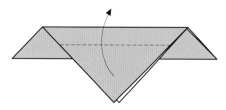

Take the top layer and fold up along valley line as indicated by arrow.

**4**

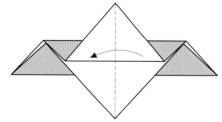

Fold left along valley line as indicated by arrow.

**5**

 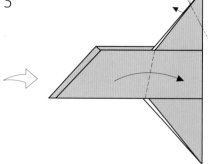 

Take the top corner and do an inside reverse fold along mountain line. Then take the trapezoid piece in the middle and fold along valley line as indicated by arrow. Repeat on the trapezoid from the reverse side. Rotate 90 degrees counterclockwise.

**6**

  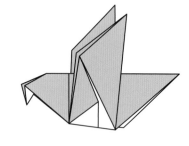

You should have the shape as shown in the diagram. This is the body of the magpie.

**7**

Use another rectangle for the magpie's tail. Fold as shown, then cut away the shaded areas. You should have the shape shown in the next step.

**8**

Apply glue to the left end of the paper and insert into the bird's tail end. Once secured, you should have the body and the tail as shown in the next step. Adjust the glue tip area as desired to make the tail point higher or lower.

**9**

 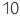 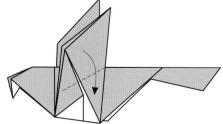

Fold down the wing along valley line as indicated by arrow. Repeat on the other side.

**10**

Mold into desired shape. Finished.

## Folding Another Kind of Magpie

Now, using a different method, we will show you another magpie.

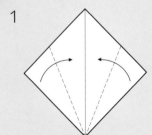

**1**

Fold along valley lines towards the center.

**2**

Fold back along mountain line as indicated by arrow.

**3**

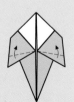

Fold along valley lines then open up to leave creases.

**4**

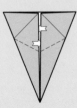

Open as indicated by arrows. Fold along valley lines. Flatten.

**5**

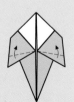

Fold up along valley lines as indicated by arrows.

**6**

Fold along valley line as indicated by arrow. Turn 90 degrees counterclockwise.

**7**

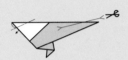

Take the left corner and inside reverse fold along mountain line. Take the right tip and cut along cut line.

**8**

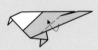

Take the bottom half of the tail and fold up along valley line, past the top half of the tail. Repeat on the reverse side.

**9**

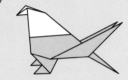

Shape to finish.

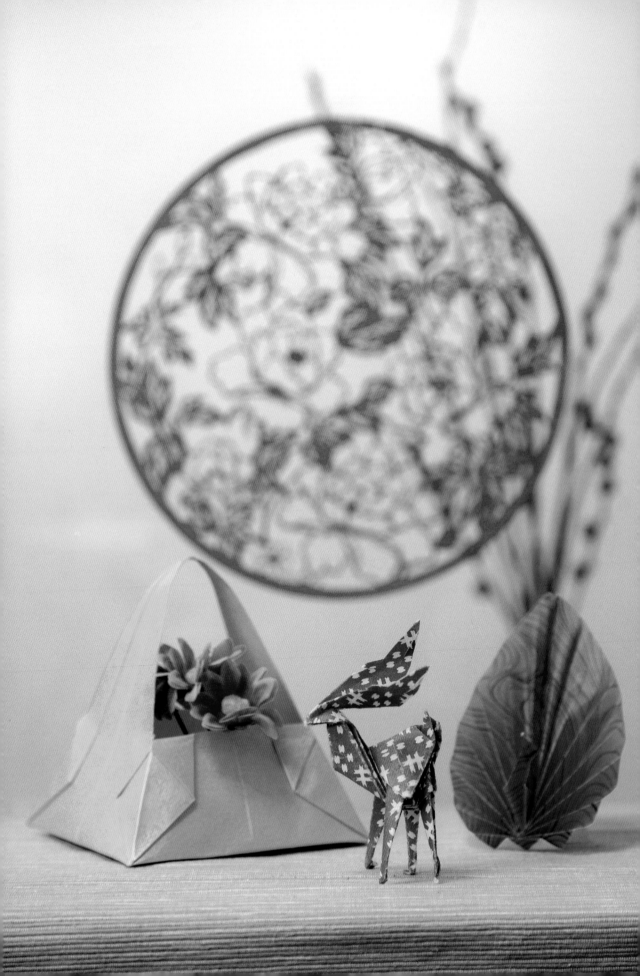

# GOOD FORTUNE AND PROSPERITY

When the deer runs, it displays a light graceful posture that is loved by many. But in China, the deer has a deeper meaning. Ancient scholars can become government officials by passing the imperial examinations; the position is one of status and greatness. Because the Chinese word for deer (鹿, *lu*) and greatness (禄, *lu*) are homophones, deer pattern has become the classic symbol of culture, and is commonly used by scholars to decorate libraries and stationery.

The peacock's tail is beautifully decorated; when open, it shines brightly and elegantly in gold and emerald. Ancient Chinese use "peacock in bloom" to symbolize peace and prosperity, wishes coming true, and renewal. Chinese folk sayings go, "whoever the peacock visits, that household will prosper." Therefore, gifts with patterns of peacock are top choices used for housewarming.

Flower baskets are very common decorative patterns. Baskets filled with different varieties of flowers have different meanings. Peony, magnolia, rose, osmanthus, chrysanthemum and plum blossoms in flower baskets denote "four seasons of wealth."

## Deer

1

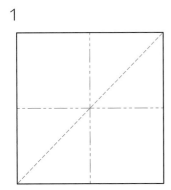

Fold along mountain and valley lines.

2

Fold open where indicated by hollow arrow, then fold along mountain and valley lines and flatten.

3

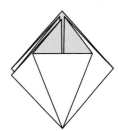

You should have the shape as shown in the diagram. Repeat step 2 on the other faces. You should have the shape shown in the next diagram.

4

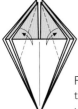

Fold along valley lines towards the center and then open back up to leave creases.

5

Fold open and then flatten along mountain and valley lines.

*On facing page*
A blue peacock, a red deer and a yellow flower basket sit under a large red paper-cut art in a festive ensemble.

**6**

You should have this shape. Repeat steps 4 and 5 on the other faces.

**7**

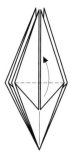

Fold up along valley line as indicated by arrow. Turn over.

**8**

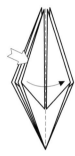

Fold two pieces from the left along valley line to the right as indicated by arrow.

**9**

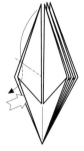

Inside reverse fold along mountain line as indicated by arrow.

**10**

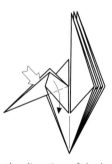

Fold open in the direction of the hollow arrow and then fold down along valley line.

**11**

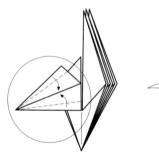

Fold along valley lines towards the center as indicated by arrow.

**12**

Fold up along valley line as indicated by arrow.

**13**

You should have the shape as shown in the diagram.

**14**

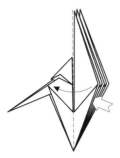

Fold two pieces from the right to the left as indicated by arrow.

**15**

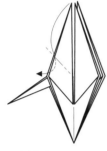

Inside reverse fold along mountain line as indicated by arrow. You should have the shape shown in the next diagram.

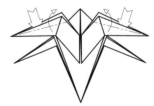

**16**

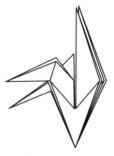

Repeat steps 8 through 15 on the right half (but reverse all directions). You should have the shape shown in the next diagram.

**17**

Fold in along mountain lines a indicated by arrow, same as steps 12 through 13.

**18**

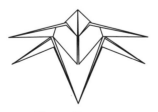

Flatten. Turn over.

**19**

Fold open as indicated by the hollow arrows. Cut along the cut line as shown.

**20**

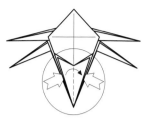

Fold to the right along valley line as indicated by arrow. Rotate 90 degrees counterclockwise.

**21**

In the zoom area, cut along cut lines.

**22**

Fold along mountain and valley lines to create deer antlers.

**23**

Fold along mountain and valley lines.

**24**

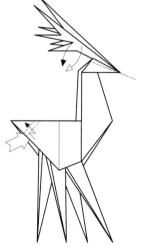

Tail: pleat fold then do an inside reverse fold. Neck: outside reverse fold. Head: inside reverse fold. Take each antler and fold down along valley lines.

**25**

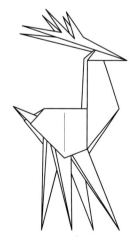

Lift up the antlers slightly. Shape. Finished.

# Peacock

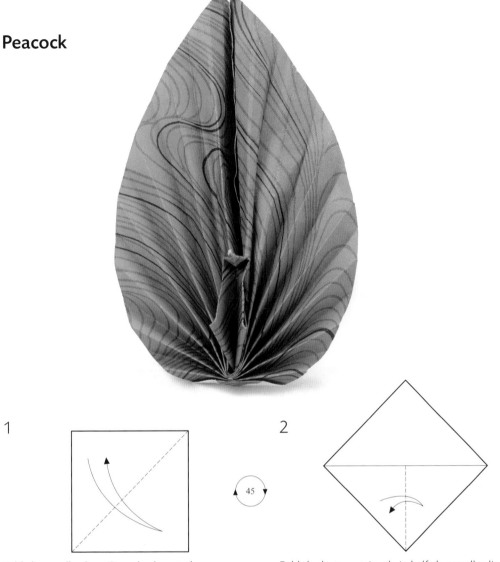

**1**

Fold along valley line. Open back up to leave a crease. Turn clockwise 45 degrees.

**2**

Fold the bottom triangle in half along valley line as indicated by arrow. Open back up to leave a crease.

**3**

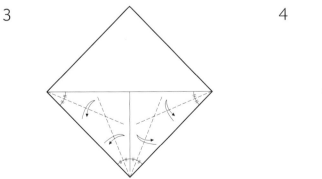

Fold along the four valley lines as indicated by arrows. Open back up to leave a crease.

**4**

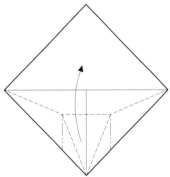

Fold up along valley and mountain lines as indicated by arrows. You should have the shape shown in the next diagram.

5

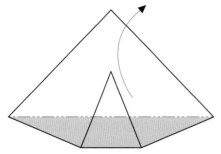

Fold back the triangle on the top half along mountain line.

6

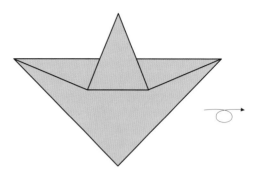

You should have this shape by now. Turn over.

7

Take the triangle and pleat fold along mountain and valley lines into 16 sections. The more folds, the more creases on the peacock's tail.

8

You should have this shape by now. Fold along vertical mountain line (midline) towards the back.

9

You should have this shape by now. Rotate 90 degrees counterclockwise.

10

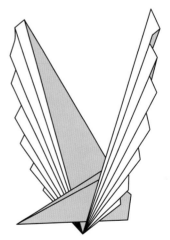

The peacock tail appears.

11

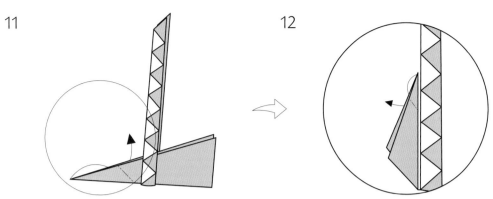

Side view. Take the front triangle and fold up, inside reverse fold along mountain line.

12

Inside reverse fold along mountain line.

13

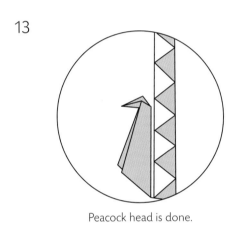

Peacock head is done.

14

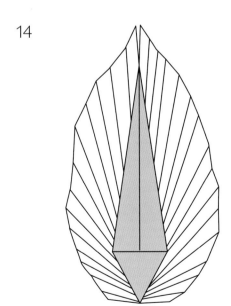

Apply glue to join the two halves of the tail. Finished.

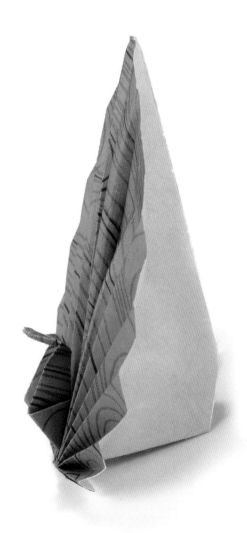

# Flower Basket

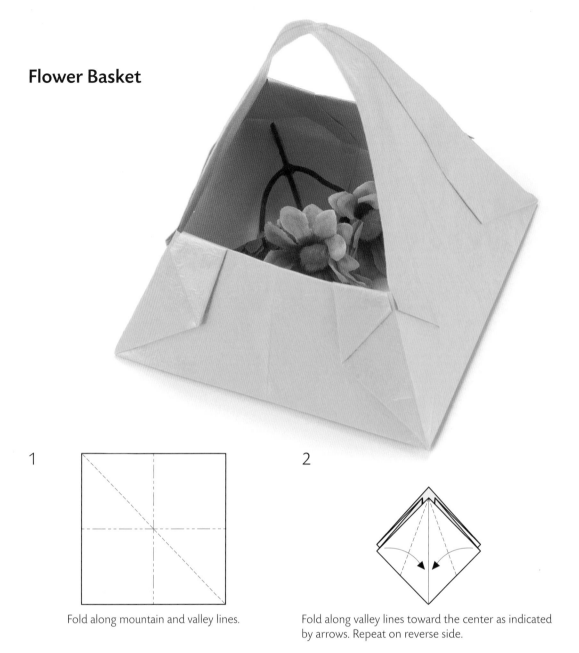

1

Fold along mountain and valley lines.

2

Fold along valley lines toward the center as indicated by arrows. Repeat on reverse side.

3

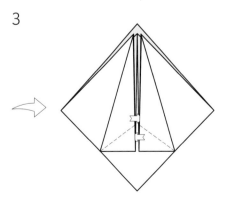

Open as indicated by hollow arrows. Flatten along mountain lines.

4

You should have the shape as shown in diagram. Repeat on reverse side.

**5**

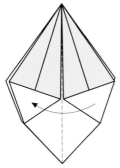

Reverse fold along valley line as indicated by arrow. Do the same reverse fold on the other side.

**6**

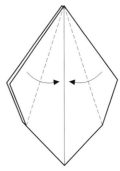

Fold along valley lines towards the center line as indicated by arrows. Repeat on reverse side.

**7**

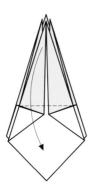

Fold down along valley line. Repeat on reverse side.

**8**

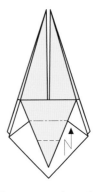

Do a pleat fold along mountain and valley lines. Do the same on reverse side.

**9**

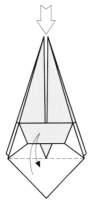

Fold along valley line, then open back up to leave a crease. Open up as indicated by hollow arrow, then mold along crease line to create a square as the base for the basket.

**10**

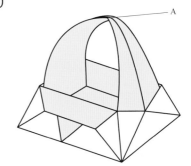

Fold up and secure the handle using glue at point A in diagram. Mold into shape to finish.

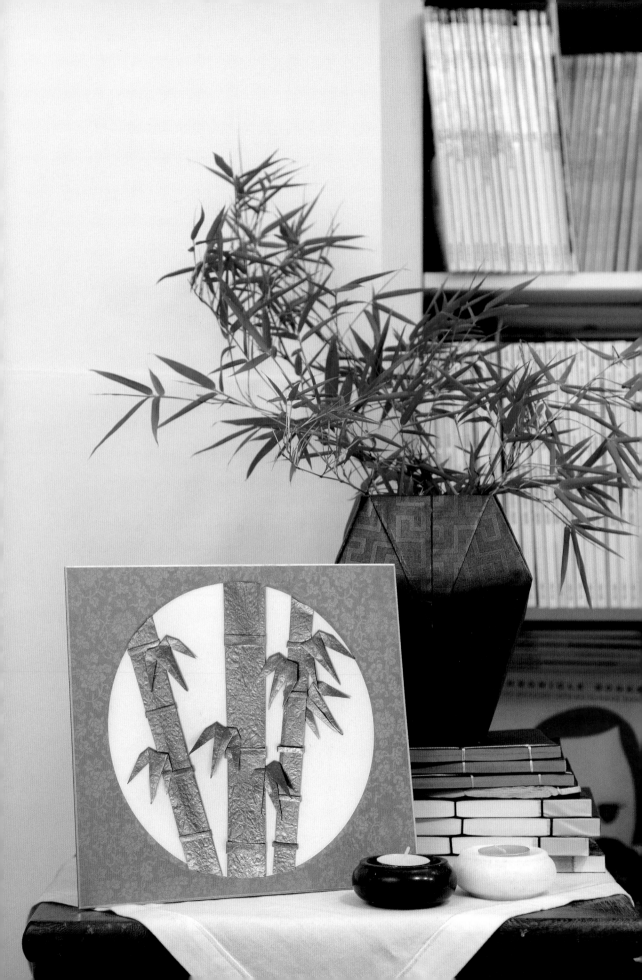

# PEACE

Bamboos grow tall and slender, are lush green through the four seasons and are fierce against frost and rain. It is one of the "Four Noble" characters. There is a folklore called "Bamboo Report News of Peace." At a temple in the north, there stood a cluster of tall bamboo. Would the bamboo, usually grown in the south, be able to survive the test of cold winters in the north? The monk in charge of temple affairs gave daily reports that the bamboo had not withered and were living quite peacefully. Since then "Bamboo Report News of Peace" referred to news of peace, which is how it became a symbol of it. The ancient Chinese poets and literati used bamboo often in their paintings as a theme and tribute.

In traditional Chinese marriage customs, the dowry always included the flower vase, which can be porcelain or glass. Because the word for vase (瓶, *ping*) and peace (平, *ping*) are homophones, vases have come to symbolize peace. Vases should be round to symbolize "full circle and wholeness."

## Bamboo

### Bamboo Leaf

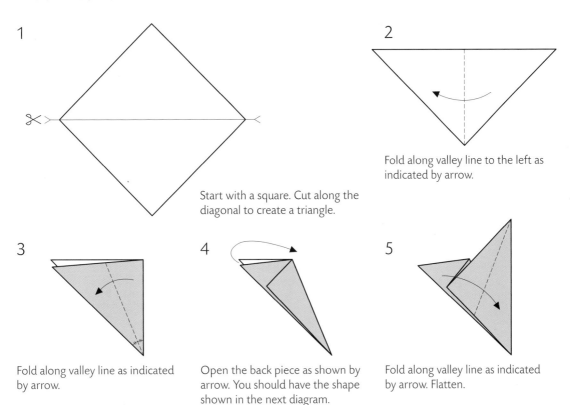

1  Start with a square. Cut along the diagonal to create a triangle.

2  Fold along valley line to the left as indicated by arrow.

3  Fold along valley line as indicated by arrow.

4  Open the back piece as shown by arrow. You should have the shape shown in the next diagram.

5  Fold along valley line as indicated by arrow. Flatten.

*On facing page*
Long bamboo stems sit quietly in a vase to express wishes of peace.

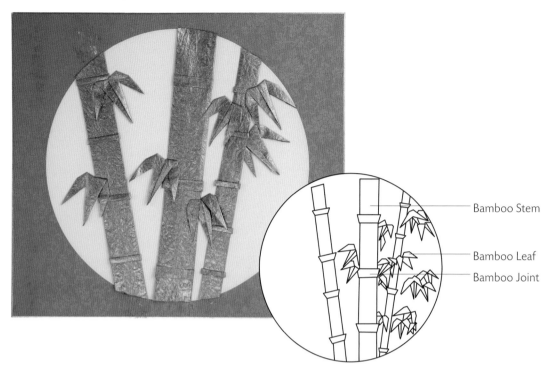

Bamboo Stem

Bamboo Leaf
Bamboo Joint

Bamboo is created with three parts: stem, joint and leaf. You can use glue to attach the three parts to create a bamboo plant.

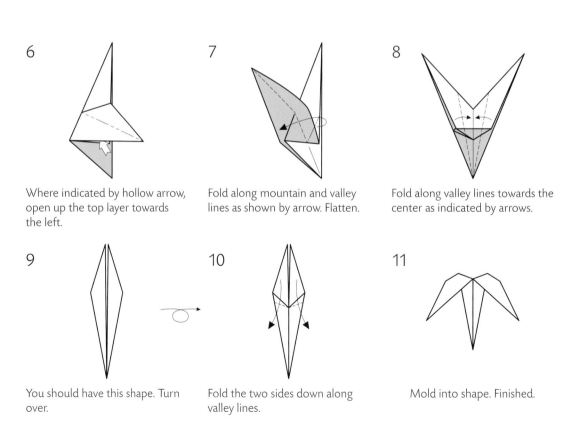

6

Where indicated by hollow arrow, open up the top layer towards the left.

7

Fold along mountain and valley lines as shown by arrow. Flatten.

8

Fold along valley lines towards the center as indicated by arrows.

9

You should have this shape. Turn over.

10

Fold the two sides down along valley lines.

11

Mold into shape. Finished.

## Bamboo Stem

1

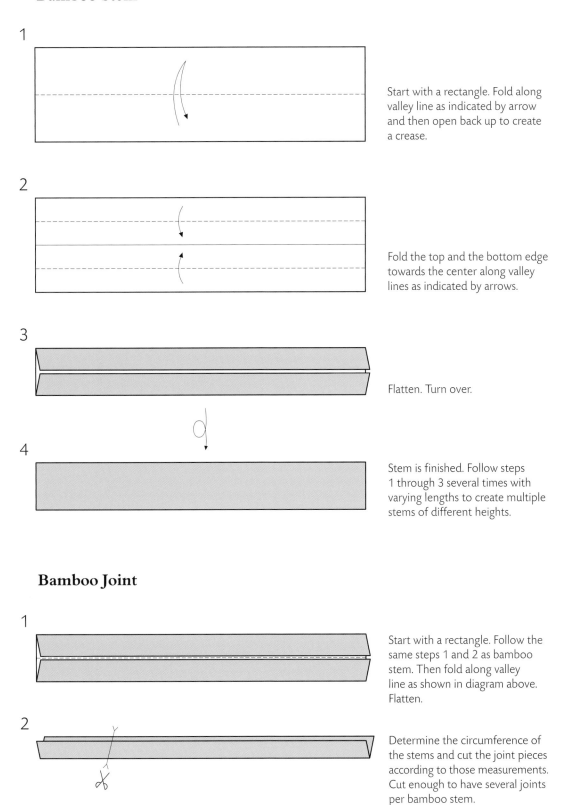

Start with a rectangle. Fold along valley line as indicated by arrow and then open back up to create a crease.

2

Fold the top and the bottom edge towards the center along valley lines as indicated by arrows.

3

Flatten. Turn over.

4

Stem is finished. Follow steps 1 through 3 several times with varying lengths to create multiple stems of different heights.

## Bamboo Joint

1

Start with a rectangle. Follow the same steps 1 and 2 as bamboo stem. Then fold along valley line as shown in diagram above. Flatten.

2

Determine the circumference of the stems and cut the joint pieces according to those measurements. Cut enough to have several joints per bamboo stem.

# Flower Vase

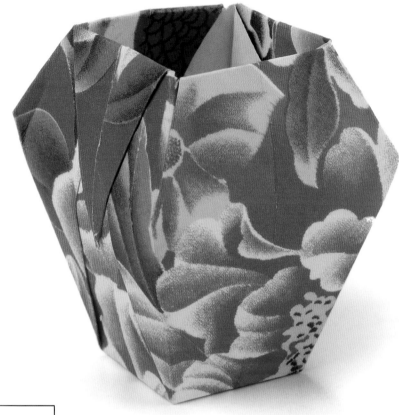

1

Fold along mountain and valley lines.

2

Fold along valley lines towards the center line as indicated by arrows.

3

You should have this shape so far. Repeat step 2 on reverse side.

4

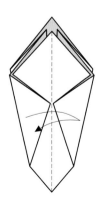

Fold as indicated by arrow, then open back up to leave a crease in the center line.

**5**

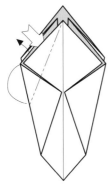

Open up as indicated by arrow. Do an inside reverse fold along mountain line.

**6**

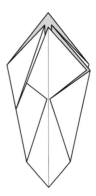

Repeat step 5 on the back and on the right side.

**7**

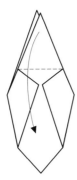

Fold the top triangle downward, along valley line as indicated by arrow. Secure with glue. Repeat on reverse side.

**8**

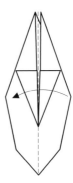

Fold over along valley line as indicated by arrow. Repeat on other side.

**9**

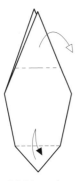

Take the bottom and fold up along valley line, then open back up to leave a crease. Take the top part and fold along mountain line, then secure with glue. Repeat on reverse side.

**10**

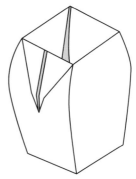

Open up the inside. For the bottom, press down along the crease created from step 9. Mold into shape to finish.

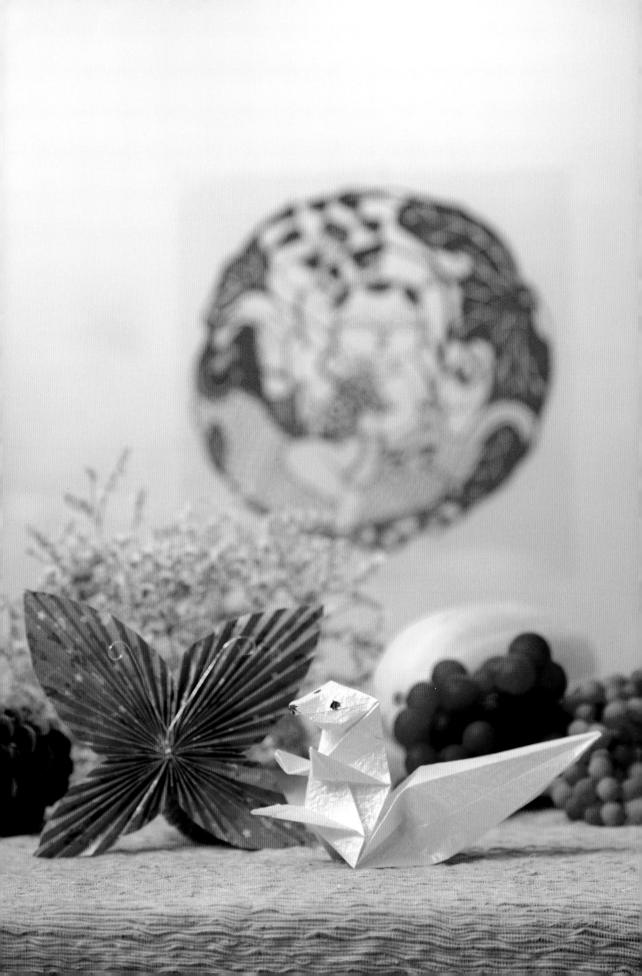

# BLESSINGS OF MORE CHILDREN

Squirrels are cute, lovable, clever and well behaved. In the ancient Chinese method of calculating hours, the squirrel represents the "hour of children" (11 p.m. to 1 a.m.), and has the metaphor for "having children." Clusters of grapes symbolize "plenty." So squirrels and grapes are often used together to represent "many children," "harvest" and "richness."

Melons are often quite small when they are young, but their vines stretch far for breeding, spreading seeds and growing in abundance. The Chinese characters for butterfly (蝶, *die*) and young melon (瓞, *die*) are homophones. Therefore, folks often use butterfly to paint a blessing of abundant children and a wealth of fortune.

## Squirrel

1

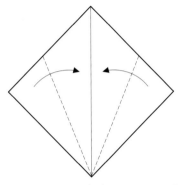

Fold along valley lines towards the center as indicated by arrows.

2

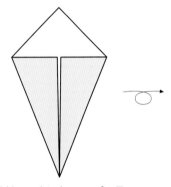

You should have this shape so far. Turn over.

3

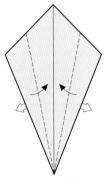

Fold along valley lines towards the center as indicated by arrows. Then take the triangles from the back side and fold out where indicated by hollow arrows.

4

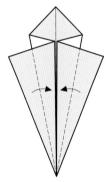

Fold along valley lines towards the center as indicated by arrows.

*On facing page*
Butterfly and squirrel cleverly express a blessing of many children.

5

Where indicated by arrows, fold down along mountain and valley lines to form a diamond as shown in the next diagram.

6

Fold along mountain and valley lines to create a diamond as directed by arrows.

7

On the left side, fold to the back along mountain line as indicated by arrow.

8

Inside reverse fold along mountain line.

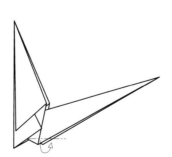

9

Follow mountain line, take the front piece and fold inside as indicated by arrow. Repeat on the back piece but reverse the direction.

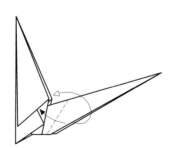

10

Outside reverse fold along valley line.

**11**

Fold up along valley line as indicated by arrow.

**12**

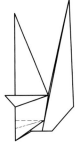

Fold up along valley line. Then fold down along mountain line. Repeat on other side.

**13**

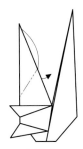

Inside reverse fold along mountain line.

**14**

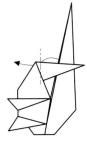

Inside reverse fold along mountain line.

**15**

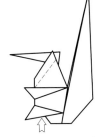

Fold along valley line and do the same on the other side. Where indicated by hollow arrow, open up 90 degrees on the bottom to make it upright.

**16**

Use a finger to push the head upward where indicated by hollow arrow. Press into shape. Refer to zoom views of next diagram for how to fold the head.

**17**

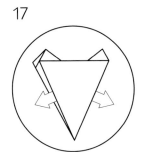

Pull out the two sides of the head as indicated by arrows.

45

**18**

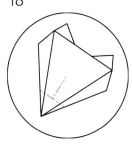

Shape along mountain and valley lines to create a corner and then fold this corner inward.

**19**

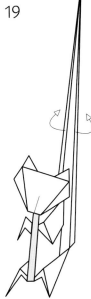

Spread the tail toward the two sides and press down. Shape to finish.

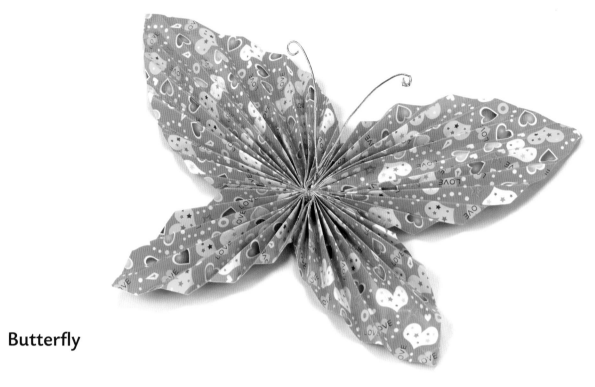

# Butterfly

1

Make pleat folds along mountain and valley lines.

2

You should have the shape as shown in the diagram.

3

Flatten and press hard to form creases for the butterfly's front wings. Take another piece of paper, slightly smaller than the first piece. For example, use 15 x 15 cm for the front wings and 11 x 11 cm for the hind wings. Repeat steps 1 through 3 to create the butterfly's hind wings.

4

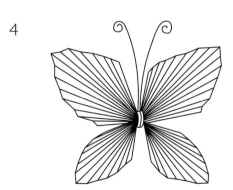

Use golden wire to wrap together the centers of the front wings and hind wings. Spread out the pleats neatly. Then use the golden wire to create the butterfly's antennae.

# LONGEVITY

Longevity is a blessing. According to the *Book of Rites*: "At age fifty, you have authority over the household. At sixty, you have authority over the village. At seventy, you have authority over the country. At eighty, you can enter and exit the palace as you please. At ninety, you are a national treasure, even the king has to give his respects." There are many symbols of blessing for longevity in Chinese culture.

The Taoist tradition brought the crane into the spiritual world. The crane has come to embody high ideals and far-reaching goals. The enlightened ride the crane and the ones reaching for enlightenment keep cranes as company. The crane's far looking gaze, gingerly step and elegant composure have endeared them to the hearts of the people.

The turtle is said to have absorbed the spirit and aura of Heaven and Earth. Since ancient times, the turtle has come to symbolize longevity and the coming of good fortune.

In Taoist scripture, the Old Man of the South Pole, who determines fate, always carries a peach as he sends blessings of joy and longevity. Therefore, the peach has come to symbolize longevity. In another moving tale, the ancient Chinese military strategist Sun Bin left home at the age of eighteen to pursue military training a thousand miles away from home. In twelve years, he only went home once. One day he suddenly realized it was his mother's eightieth birthday. He took leave from training to go home, and his master sent him home with a peach. When Sun Bin's mother ate the peach, she became rejuvenated. So people followed suit and continued to give gifts of peaches during birthdays of the elderly.

## Crane

1

Fold along mountain and valley lines.

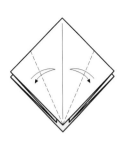

2

Fold along valley lines then open back up to leave creases.

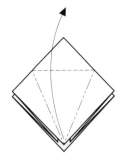

3

Fold along mountain and valley lines, then open back up as directed by arrow, flatten to form a diamond as shown in diagram of next step.

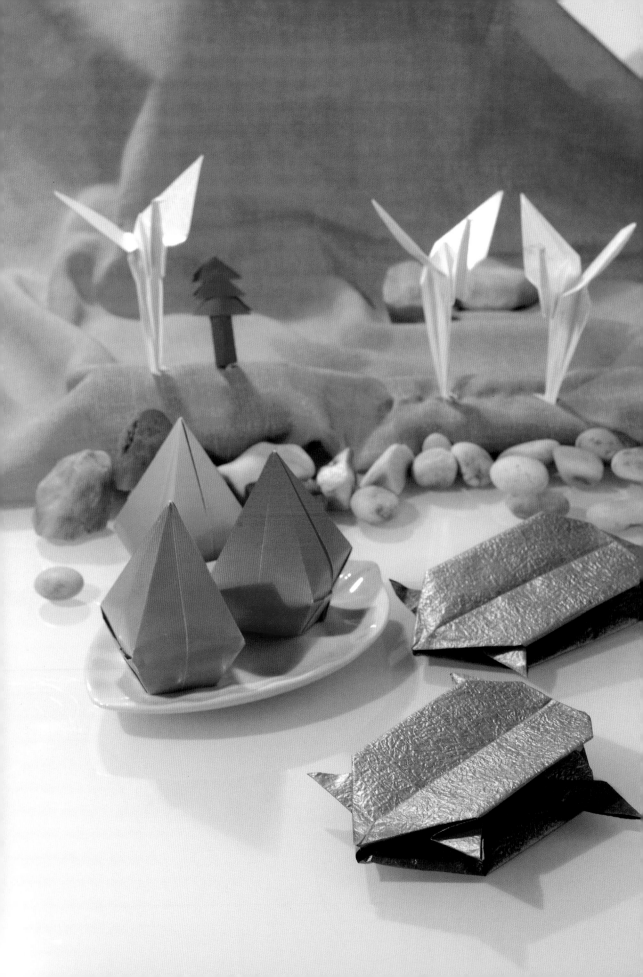

**4**

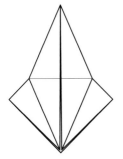

Turn over. Repeat steps 2 and 3.

**5**

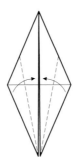

Fold along valley lines towards the center as indicated by arrows. Repeat on reverse side.

**6**

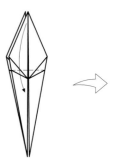

Fold down along valley line as indicated by arrow. Repeat on reverse side.

**7**

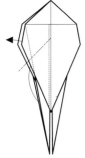

Inside reverse fold up the triangle on the left along mountain line.

**8**

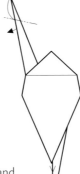

Take the top tip and inside reverse fold down along mountain line. For the bottom, cut along the halfway line to form the crane's two legs.

**9**

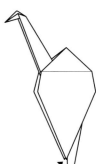

For the bottom, inside reverse fold along mountain line.

**10**

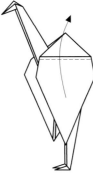

Reverse fold up along valley line to expand the crane's wing. Repeat on reverse side. Mold into shape to finish.

*On facing page*
In Chinese culture, peaches, turtles and cranes are typical symbols of longevity. You can see them in many places.

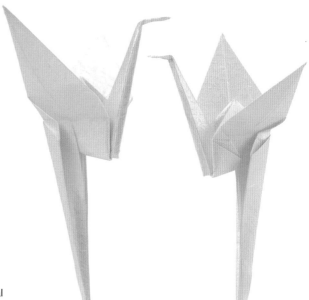

# Turtle

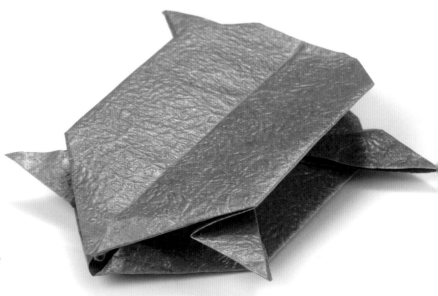

## 1

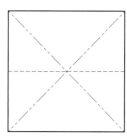

Fold along mountain and valley lines.

## 2

Fold along valley lines toward the center line. Repeat on reverse side.

## 3

Fold down along valley line as indicated by arrow. Repeat on reverse side.

## 4

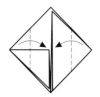

Fold along valley lines towards the center as indicated by arrow. Repeat on reverse side.

## 5

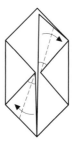

Fold along valley lines as indicated by arrows. Repeat on reverse side.

## 6

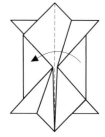

Reverse fold as indicated by arrow. Repeat on reverse side.

## 7

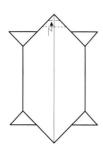

Do one pleat fold along mountain and valley lines to form the turtle's head.

## 8

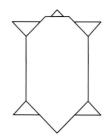

Finished.

# Peach

1

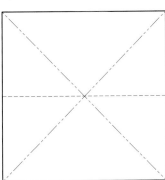

Fold along mountain and valley lines.

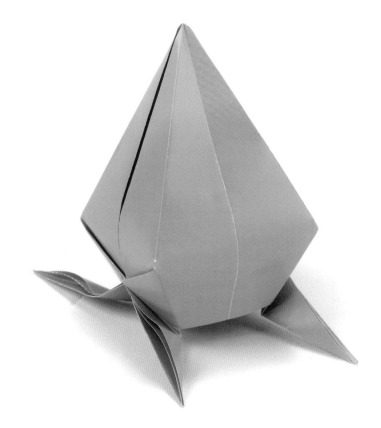

2

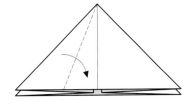

Fold along valley line as indicated by arrow.

3

Fold along valley line as indicated by arrow.

4

Fold along valley line as indicated by arrow.

5

You should have the shape shown in the diagram. Repeat the same folds on the other three flaps.

6

Open up. Finished.

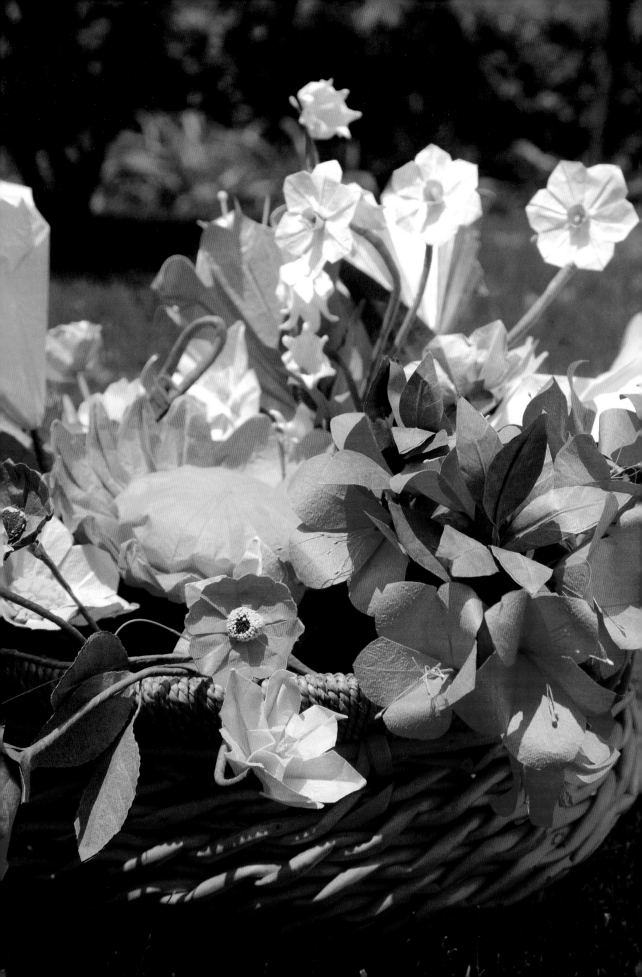

# Chapter 4

# ADVANCED FLOWERING PLANTS

As an ancient civilization, China has thousands of years of history in flower cultivation because its vast geography has allowed a richly resourced and wide assortment of flowers. Aside from being objects of enjoyment, flowers are praised for their character in paintings and poems. For example, in Chinese art, the Four Noble Ones refer to four flowering plants and their characters: plum blossom (courage), orchid (integrity), bamboo (strength) and chrysanthemum (nobility). Everyone can enjoy viewing flowers to cheer up; on different holidays, flower names are incorporated into greetings and sayings, in order to bring about a life of joy and fulfillment.

While flowering plants in nature are vibrant and fragrant, folded paper flowers have their own share of interest because they are a fusion of imagination and creativity. To fold a vivid floral art piece, you not only have to master the blossom itself, the sepal, pistils, leaves and stem are also critical. Based on the foundation from the previous chapters, this chapter will teach you how to fold more intricate flowers. Using the same folding methods, different basic shapes can be folded into an ever-changing variety of flowers.

Compared to previous examples, techniques for folding flowers are more difficult. This is because:

1. In nature, there are thousands of species of flowers. Each species has its own blossom, sepal, pistil and leaf. To fold a lifelike flower, meticulous observations are needed to discover the natural laws of each species. Once each flower is understood for its unique characteristics, the geometric principles of paper folding, paper texture, and an unleashing of imagination are all necessary before a flower pattern can be created.

2. When folding flower designs, the paper can be fragile and can break easily. Therefore, when selecting materials, paper toughness is a key factor. However, with much practice, breaks and tears can be prevented.

3. In the many different parts of the flower, the corolla—or petals—is the most difficult to fold. Full, lush flowers bring cheer; while withered, flat petals are lifeless. Therefore, during the creative process for flower patterns, one must consider how to give the blossom a full, three-dimensional shape that will hold its shape for a long time.

4. In the folding process, different cutting angles can dramatically change how dense or sparse the petals appear. A thorough understanding of each technique is necessary in order to give rich colors to your world of flowers.

*On facing page*
Paper of various thickness, material, colors and sizes are used to fold different varietals of flowers.

# BASES

Even though there are many folded flowers, the central theme remains the same: the most important part is to master the bases. Categorized by their unique characteristics, the two types of bases are Boat Base (Horizontal Base) and Mountain Base (Pointed Base). The top of the Horizontal Base is flat; the top of the Pointed Base resembles a mountain.

Using these two bases as foundation, combined with an assortment of polygons and pointed stars, we can create a variety of flowers. The following two charts introduces how to use the basic shapes from Chapter 1 to create the corresponding Horizontal and Pointed Bases.

## Boat Base (Horizontal Base)

|  | Equilateral Triangle | Square | Pentagon |
|---|---|---|---|
| Baic Shape | | | |
| Basic Boat Base | | | |
|  | Hexagon | Octagon | Hexadecagon |
| Baic Shape | | | |
| Basic Boat Base | | | |

# Mountain Base (Pointed Base)

| | Triangle or Three-Pointed | | Square or Four-Pointed | |
|---|---|---|---|---|
| Baic Shape | | | | |
| Basic Mountain Base | | | | |

| | Pentagon or Five-Pointed | | Hexagon or Six-Pointed | |
|---|---|---|---|---|
| Baic Shape | | | | |
| Basic Mountain Base | | | | |

| | Octagon or Eight-Pointed | | Hexadecagon or Sixteen-Pointed | |
|---|---|---|---|---|
| Baic Shape | | | | |
| Basic Mountain Base | | | | |

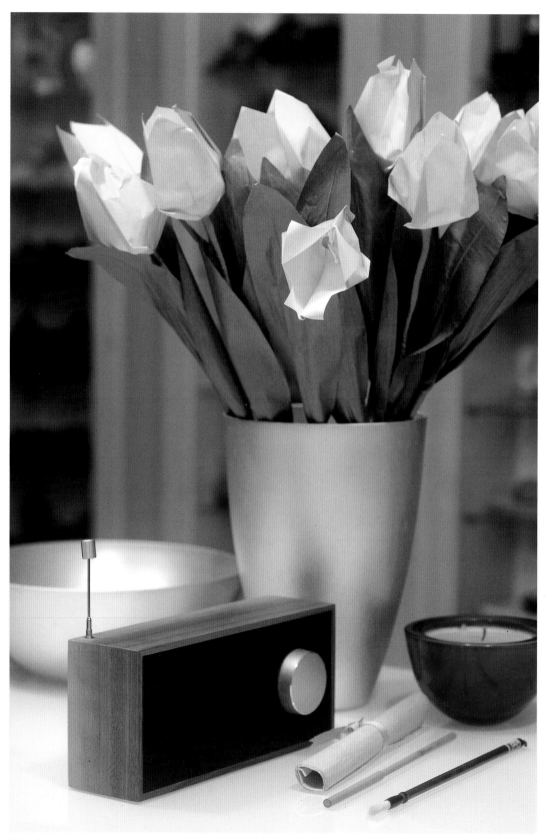

Tulips have pot-shaped corollas; they are brilliantly colorful and change shape often. Their green stalks have a graceful arc and their leaves are long. Different color tulips all have their specific names. For example, the fire-red tulip is called "Spartacus." The mysteriously dark one is called "Queen of the Night." A white tulip with red edges is called "Lady of China."

# Corolla (Petals)

The corolla is the main part of a flower, and is also the most brilliant and beautiful part of the flower. Petals form the corolla; the shape, size and balance of petals make up the look of the corolla.

This section below introduces different folding methods for corollas of various shapes. You can start with any of the pointed bases or horizontal bases, and follow the same folding methods as above, but add some twists as shown below.

The pot-shaped corolla is overall spherical, with a top that tapers to a narrow opening like a tulip. Using different regular polygons as base will affect how the top tapers.

Funnel-shaped corollas look like old-fashioned speakers, with a bottom that elongates into a tube shape. Examples are morning glory and amaryllis. The funnel can be spread open or flattened as needed during the shaping process.

Bell-shaped corollas are short and fat, such as the Chinese bellflower and the lily.

Radial flowers are also called wheel-shaped flowers because they look like spokes of a wheel. The petals radiate out in all directions from the center. Radial flowers include cherry blossoms, plum blossoms and chrysanthemums, to name a few.

Inside the sections with blue background, you will learn how to add custom alterations and creative touches to the basic folds.

## Pot Shape

1

Fold along mountain and valley lines as shown.

2

Fold along valley lines towards the center line and then open back up to leave creases. The length between the crease and the center line will determine the size of the bud.

3

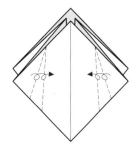

Do roll folds along the valley lines. You should have the shape as shown in the next step.

**4**

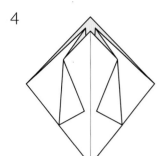

Turn over and repeat the same folds.

**5**

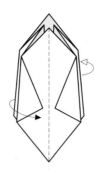

Fold over the valley line as indicated by the arrows. You should have the shape as shown in the next step.

**6**

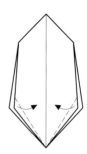

Fold up along valley lines as indicated by arrows.

**7**

You should have the shape as shown in the diagram. Repeat the same on the flip side.

**8**

Fold over the valley line as indicated by the arrows. You should have the shape as shown in the next step.

**9**

Spread open, mold into shape. Finished.

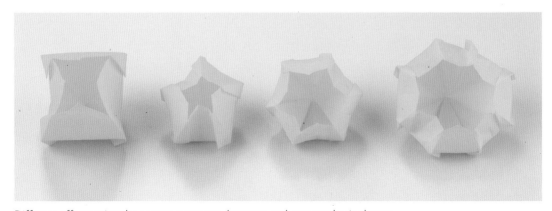

Different effects using the square, pentagon, hexagon and octagon basic shapes.

# Funnel Shape—Method 1

This method creates a longer tubular corolla, with petals that fit tighter together.

**1**

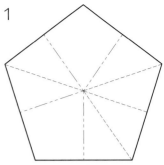

Fold along mountain and valley lines.

**2**

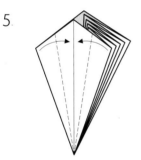

Fold along mountain and valley lines as indicated by arrow, then open and flatten.

**3**

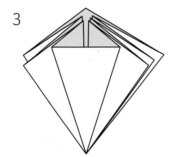

Repeat on all sides. You should have the shape as shown in the next step.

**4**

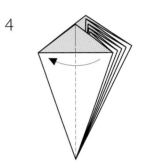

Turn the pieces from right to left as indicated by arrow.

**5**

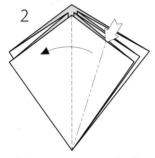

Fold along valley lines towards the center line.

**6**

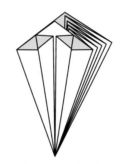

Repeat on all sides.

**7**

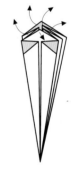

Open and mold into shape as indicated by arrows.

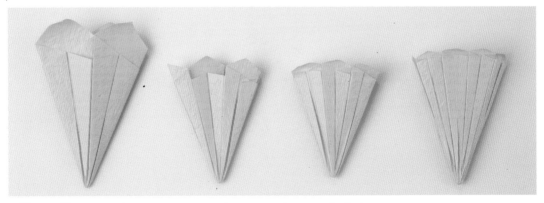

Different effects using the square, pentagon, hexagon and octagon basic shapes.

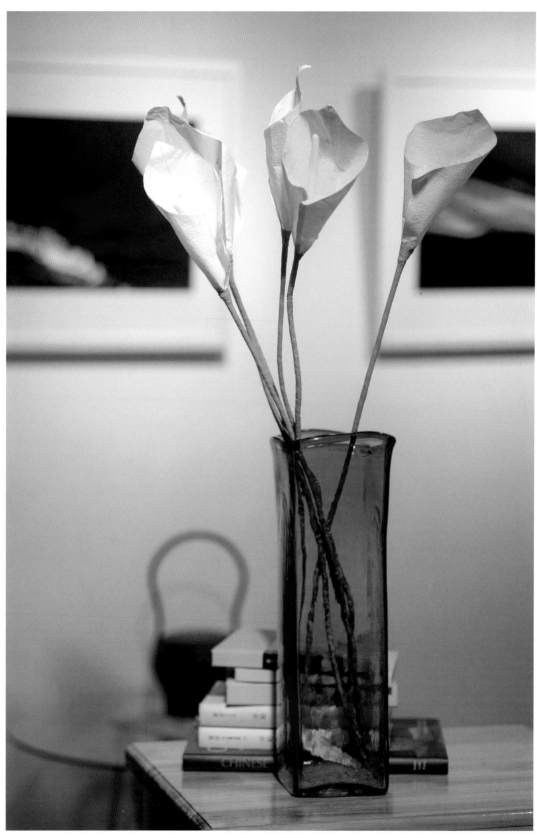

Calla lilies have large corollas shaped like horseshoes. White calla lilies are elegantly beautiful; they symbolize constant faithfulness between lovers. Yellow calla lilies symbolize sanctity, charity and holiness.

## Using Tools

This is the easiest way to create funnel-shaped flowers.

You can also use wires to secure the petals; for example, in step 1, on the two valley lines and the diagonal line, use thin wires of the same length.

Small changes can create big differences in the shape of the flower. For example, in step 1, split the top two edges into 4 equal sections, or start with different basic shapes.

1

Section the top two edges into 8 equal parts. Fold along valley lines as indicated by arrows.

2

Fold up along valley lines as indicated by arrow.

3

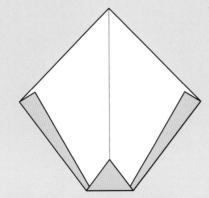

Secure the two sides with glue. Finished. Apply glue to the three colored sections.

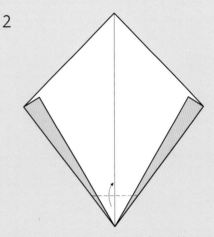

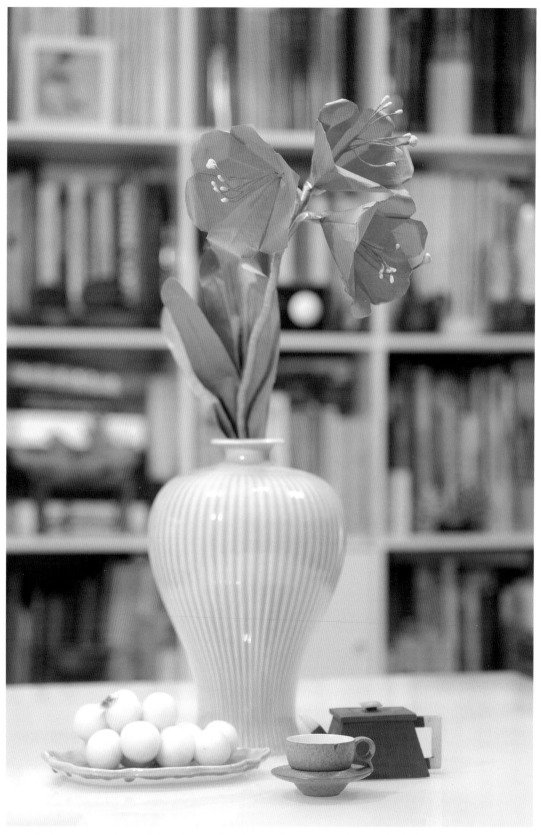

Amaryllis has a large, bulky corolla; its color is soft and pretty. They express a bold desire for love.

# Funnel Shape—Method 2

In this method, we start with regular octagons but proceed with two different basic bases: pointed base on the left and horizontal base on the right. You will see that, even though the steps are different, the results are the same. Witness the magic of paper folding!

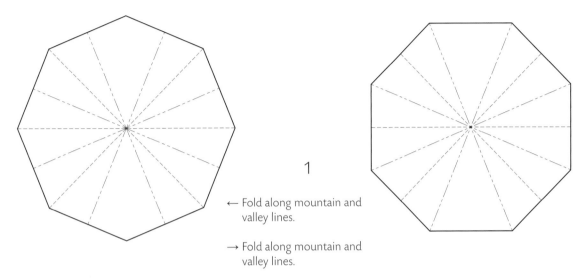

1

← Fold along mountain and valley lines.

→ Fold along mountain and valley lines.

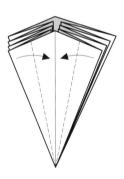

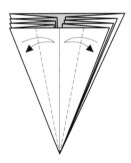

2

← Fold along valley lines towards the center line as indicated by arrows.

→ Fold along valley lines towards the center line; open back up to leave creases.

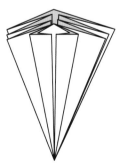

3

← Repeat on all sides. You will have the shape as shown in the next step.

→ Holding down the center mountain line, take the top left flap and fold towards the left along valley line. You will have the shapes as shown in the next step.

### 4

← Pull out two sides, as indicated by arrows.

→ Repeat on all sides.

### 5

← Pull reverse fold, down to the left and down to the right, as indicated by arrows.

→ Holding down the corner (indicated by arrow), do pull reverse fold down and to the left.

### 6

← Repeat on all sides. Open and mold into shape.

→ Repeat on each piece. Open and mold into shape.

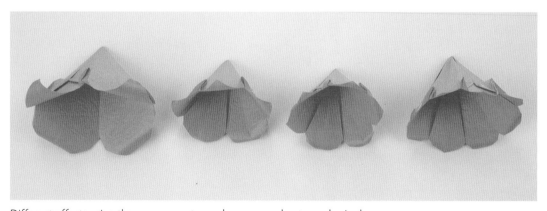

Different effects using the square, pentagon, hexagon and octagon basic shapes.

# Bell Shape—Method 1

Although the steps are the same, the pointed base on the left creates long petals, while the horizontal base on the right creates short petals.

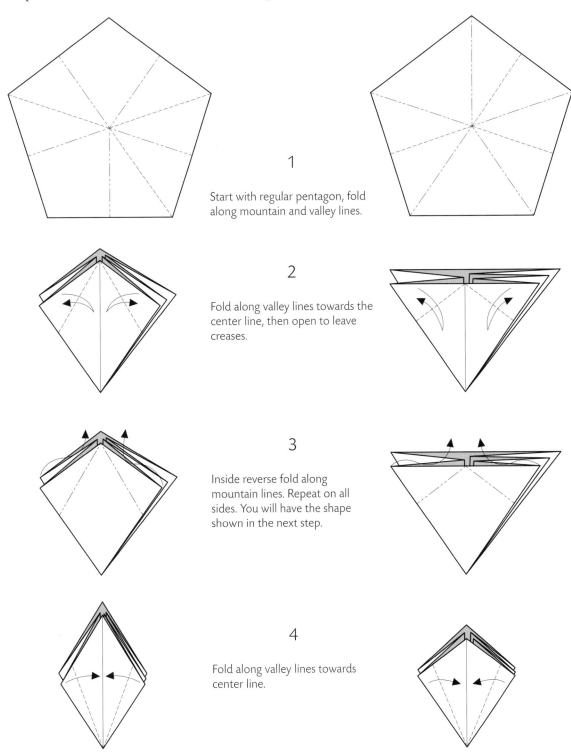

**1**

Start with regular pentagon, fold along mountain and valley lines.

**2**

Fold along valley lines towards the center line, then open to leave creases.

**3**

Inside reverse fold along mountain lines. Repeat on all sides. You will have the shape shown in the next step.

**4**

Fold along valley lines towards center line.

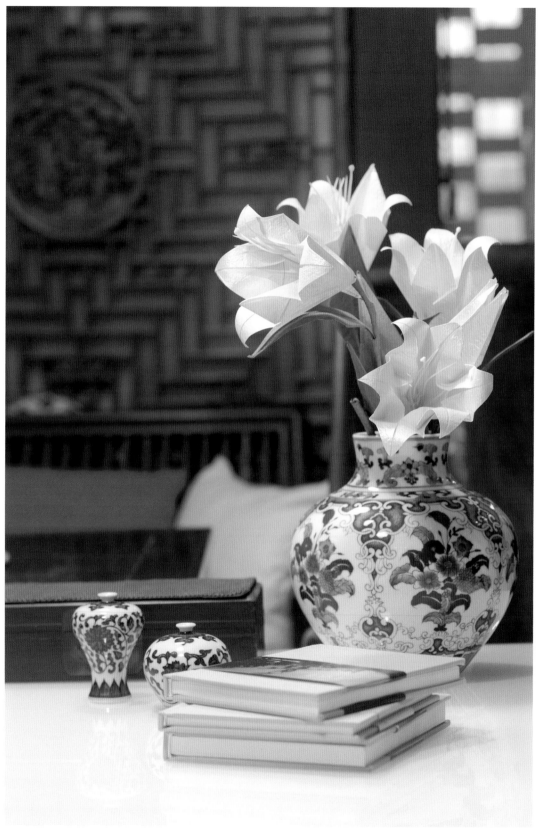

"Perfume lily" (*Lilium casa blanca*) is the queen of all lilies. Its fresh simple scent gives off a feeling of romance. In the East, lilies are viewed as auspicious flowers. Its Chinese name *baihe* signifies "hundred years of good togetherness," which makes lilies indispensible at Chinese wedding ceremonies.

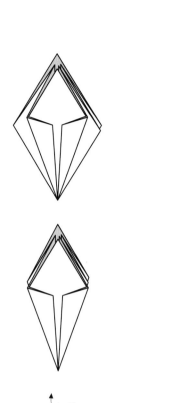
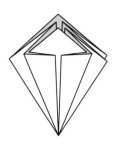

5

Repeat on all sides.

6

You should have this shape.

7

Open as indicated by arrows.
Mold into shape.

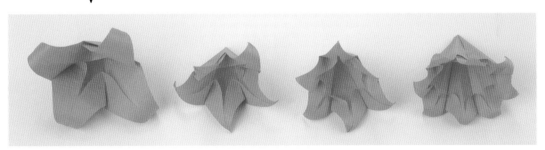

Different effects using the square, pentagon, hexagon and octagon basic shapes with pointed base.

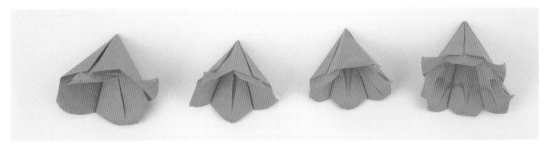

Different effects using the square, pentagon, hexagon and octagon basic shapes with horizontal base.

## Creating Rounded Petals

When creating pointed stars, cut curved lines instead of straight lines to create rounded petals. The longer the curve line, the small the angle between petals, the wider the petals spread.

1

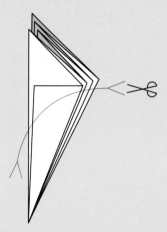

Follow the instructions for 8-pointed star on page 30, steps 1 through 3. Then cut along the curved cut lines.

2

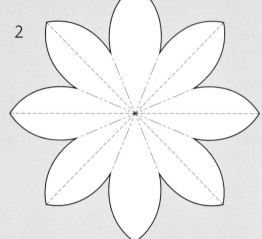

Open and you should have the shape shown. Fold along mountain and valley lines.

3

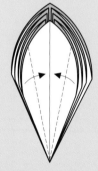

You should have this shape. Take the top two pieces and fold along valley lines. You should have the shape shown below.

4

Repeat on all sides.

5

Open as indicated by arrows. Mold into shape.

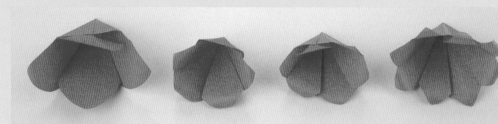

Different effects using the square, pentagon, hexagon, octagon basic shapes with round petals.

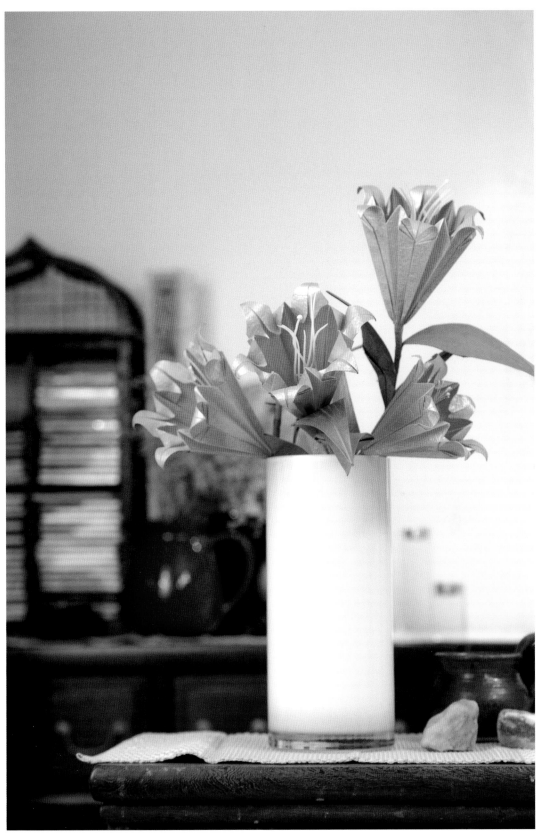

Compared to other lilies, the Easter lily tends to be longer. It has a sweet fragrance. It tends to stand up straight, and thus gives a sense of pure elegance. It is an essential decorative flower for many holidays and occasions.

# Bell Shape—Method 2

This method creates petals that are closer together and tighter.

1

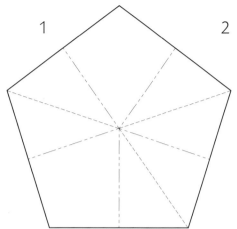

Fold along mountain and valley lines.

2

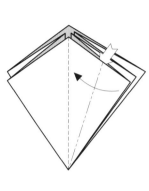

As indicated by arrows, fold open along mountain and valley lines, then flatten.

3

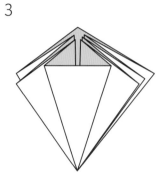

You should see this on one side. Repeat on all sides.

4

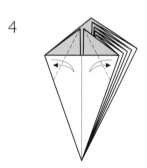

Fold along valley line towards center line. Open to leave creases.

5

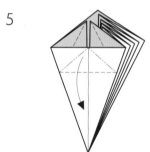

Fold down along mountain and valley lines as indicated by arrows. Flatten.

6

Take the bottom triangle and fold up along valley line.

7

Fold along valley line as indicated by the arrow. Repeat steps 4 through 6 on all sides. You will have the shape shown in the next step.

8

Fold along valley lines towards the center line. Repeat on all sides.

9

Open and mold into shape.

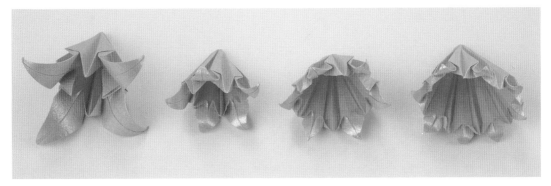

Different effects using the square, pentagon, hexagon and octagon basic shapes.

## Bell Shape—Method 3

This method creates a bell-shape corolla that hangs down. The plump shape is cute, suitable for small exquisite flowers such as orchids.

1

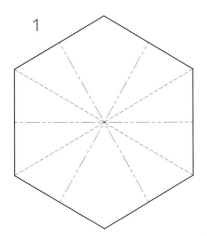

Fold along mountain and valley lines.

2

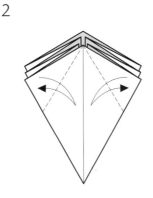

Fold along valley lines towards the center line. Open to leave creases.

3

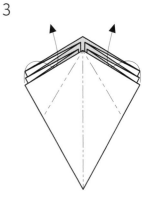

Inside reverse fold along mountain lines.

4

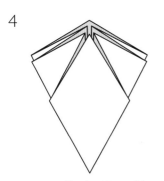

Repeat on all sides. You will have the shape as shown in the next step.

5

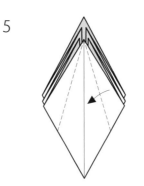

Fold along valley line towards the center line.

6

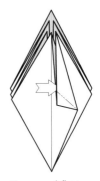

Open and flatten.

**7**

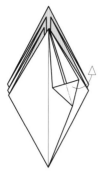

Fold back along mountain line as indicated by arrow.

**8**

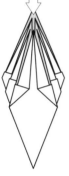

Repeat on all sides.

**9**

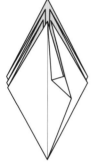

Open and mold into shape.

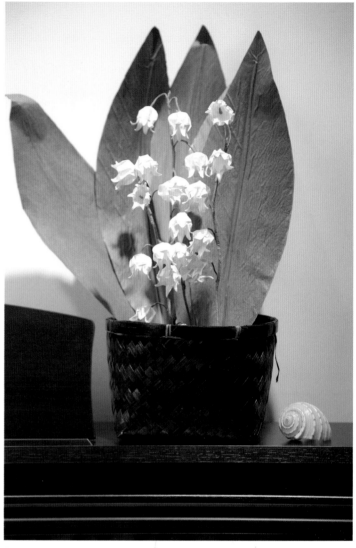

The white flowers of the bell orchid hang down like a string of delicate small bells. Bell orchids bloom with the spring breeze of May, and are a sign of the return of happiness. Even though they grow in deep valleys of forests, they emit a fragrant aroma. Because of this, in the heart of the Chinese people, the bell orchid is a symbol of noble character.

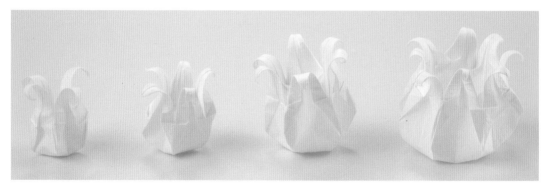

Different effects using the square, pentagon, hexagon and octagon basic shapes.

# Radial—Method 1

In Method 1, while the basic shapes on the left and right are different, the folding method is exactly the same. Pay attention to the difference between the two.

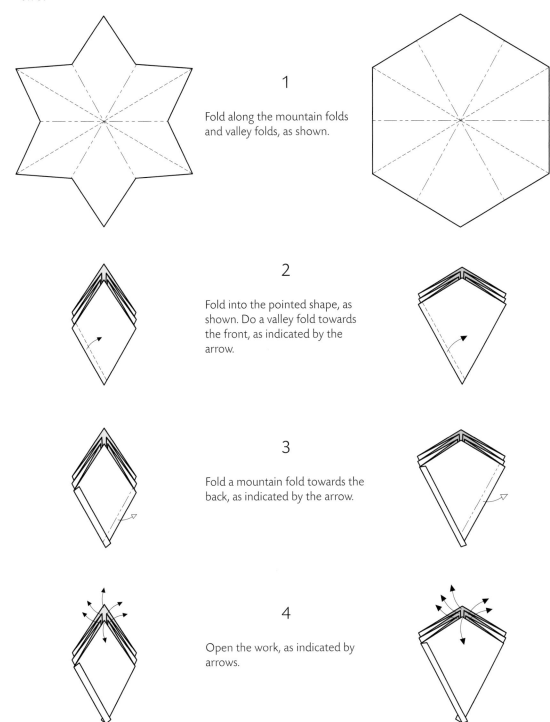

**1**

Fold along the mountain folds and valley folds, as shown.

**2**

Fold into the pointed shape, as shown. Do a valley fold towards the front, as indicated by the arrow.

**3**

Fold a mountain fold towards the back, as indicated by the arrow.

**4**

Open the work, as indicated by arrows.

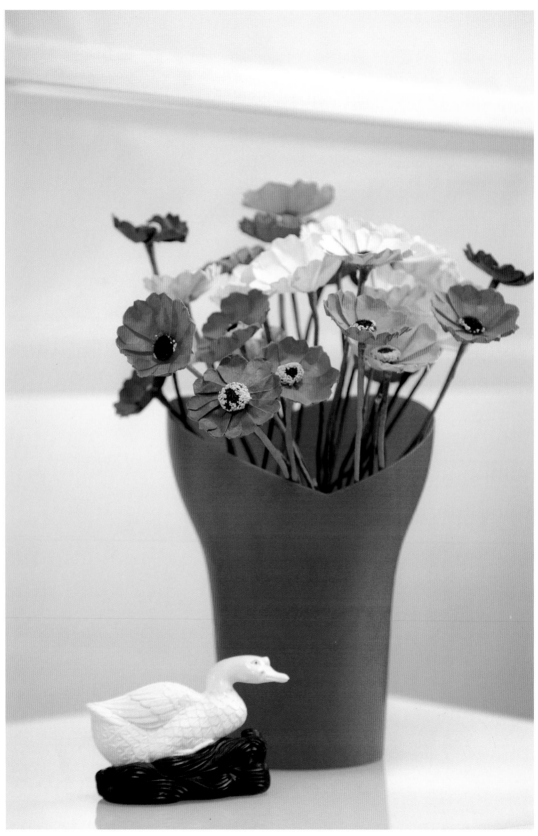

During the Spring Festival, multicolored cineraria bouquets are often used as ornamental displays. Not only do they liven the atmosphere of the Spring Festival, these flowers embody the meaning of "great luck, great riches and booming fortune."

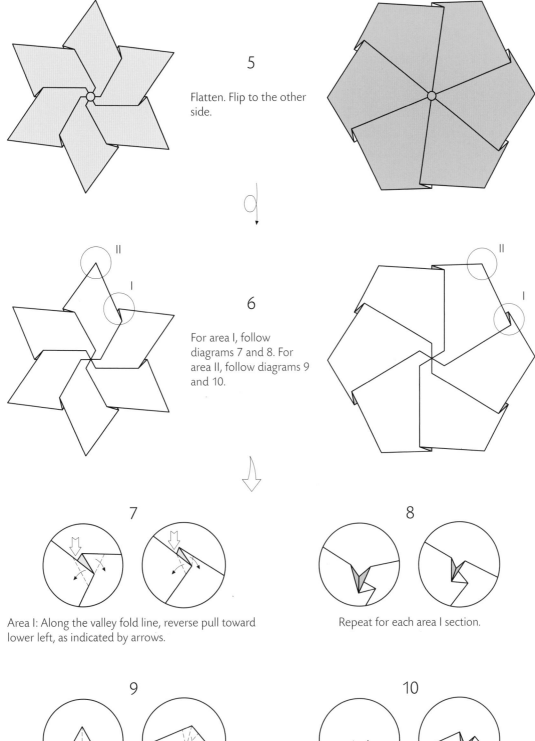

**5**

Flatten. Flip to the other side.

**6**

For area I, follow diagrams 7 and 8. For area II, follow diagrams 9 and 10.

**7**

Area I: Along the valley fold line, reverse pull toward lower left, as indicated by arrows.

**8**

Repeat for each area I section.

**9**

Area II: Hold the corner peak. Reverse fold down, as indicated by arrow.

**10**

Repeat for each area II section.

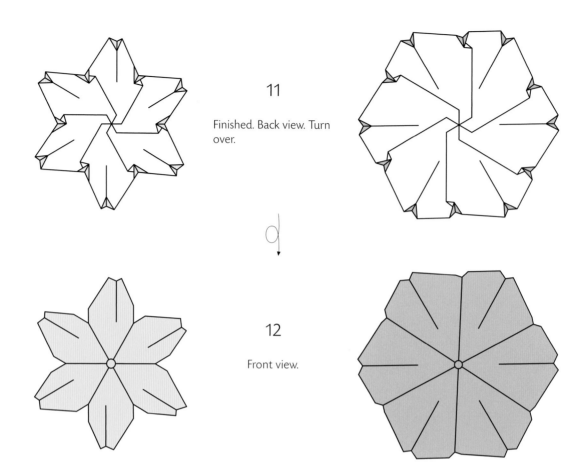

11

Finished. Back view. Turn over.

12

Front view.

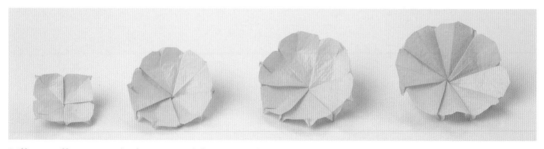

Different effects using the four-pointed, five-pointed, six-pointed and eight-pointed star basic shapes.

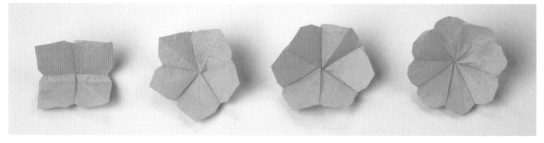

Different effects using the square, pentagon, hexagon and octagon basic shapes.

## Making Another Kind of Radial Corolla

What if we change a little to step 6 of Method 1?

Using regular hexagon as starting base, follow the above instructions steps 1 through 5. After step 5, only in between petals, i.e. area I, do outside reverse pull. This will give a different effect for the front and back.

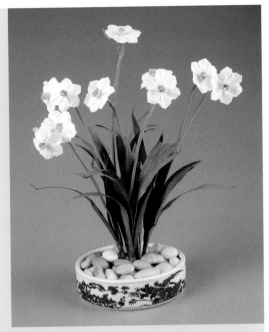

Chinese narcissus is one of the widely accepted Top Ten iconic flowers of the country. The others are the orchid, plum blossom, peony, chrysanthemum, rose, lotus, camellia, sweet osmanthus and azalea. It is often used to decorate the study room and living room, standing for purity and grace.

**1**

Outside reverse pull from area I.

**2**

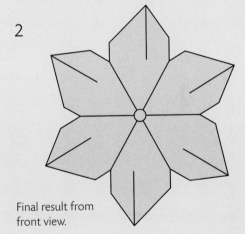

Final result from front view.

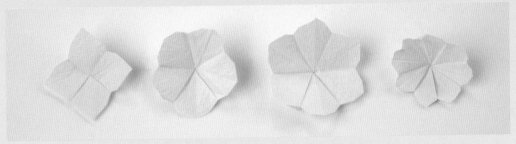

Different effects using the square, pentagon, hexagon and octagon basic shapes.

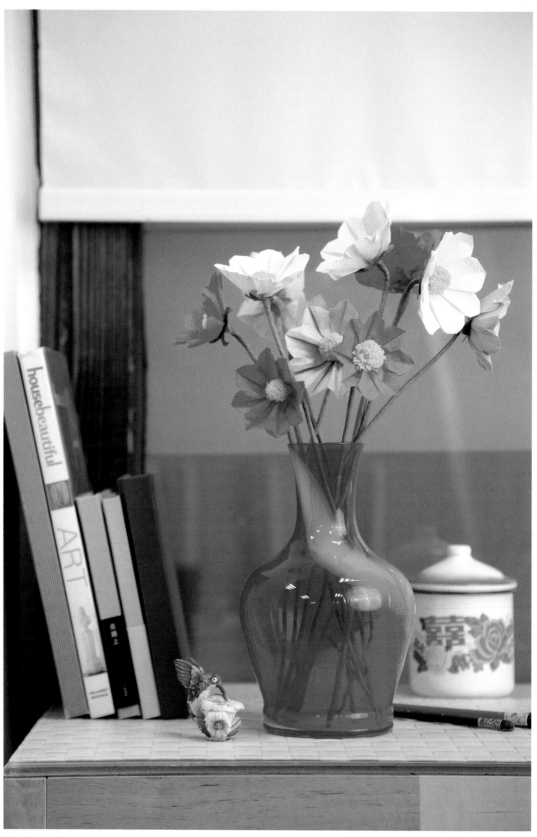

The chrysanthemum originated from China, and is one of the Top Ten iconic flowers of the country. It has a cultivation history of over 3,000 years, and is a symbol of noble character. Chrysanthemums come in many shapes and rich colors for a spectacular appearance.

# Radial—Method 2

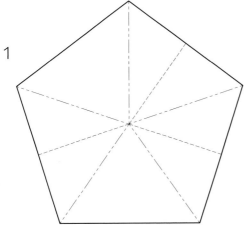

1

Start with regular pentagon. Fold along the mountain and valley lines, as shown.

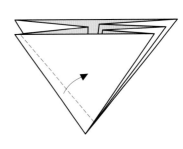

2

Fold a valley fold as indicated by the arrow.

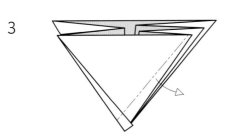

3

Fold a mountain fold towards the back as indicated by the arrow.

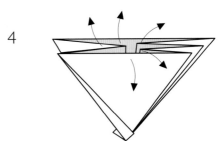

4

Open as indicated by the directions of the arrows.

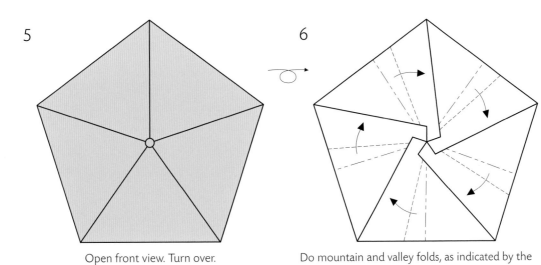

5

Open front view. Turn over.

6

Do mountain and valley folds, as indicated by the lines in the diagram.

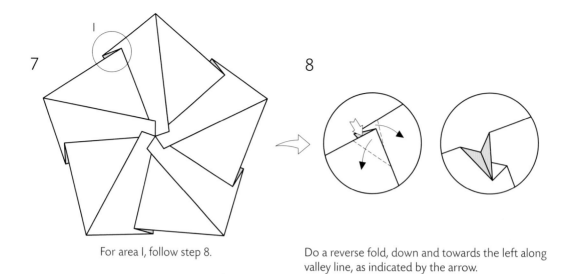

7 For area I, follow step 8.

8 Do a reverse fold, down and towards the left along valley line, as indicated by the arrow.

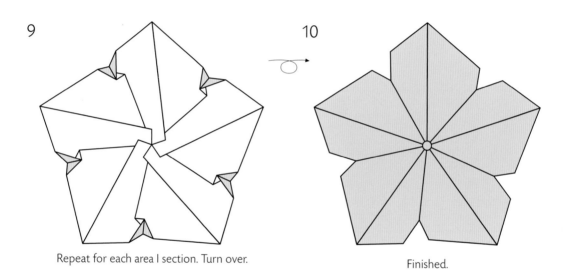

9 Repeat for each area I section. Turn over.

10 Finished.

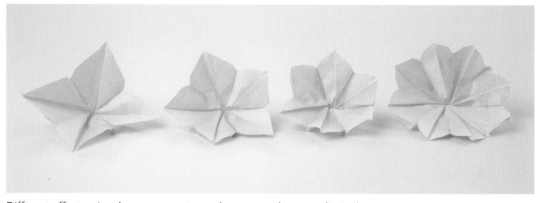

Different effects using the square, pentagon, hexagon and octagon basic shapes.

# Radial—Method 3

With this method, the resulting flower will have its own pistil, for an overall fuller effect.

1

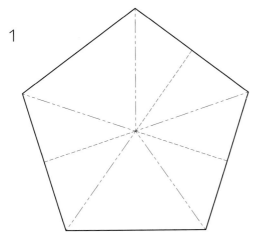

Start with a regular pentagon. Fold along the mountain and valley lines, as shown.

2

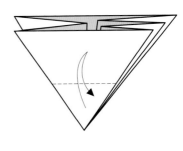

Fold up along valley line, then unfold, leaving a crease.

3

Open back up. See all the creases.

4

Fold mountain and valley folds, as shown.

5

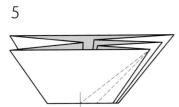

Roll-fold upward along the valley lines as shown.

6

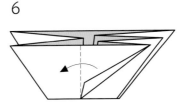

Reverse the flap as indicated by arrow.

7

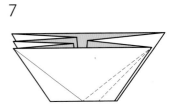

Repeat step 5 for each flap section.

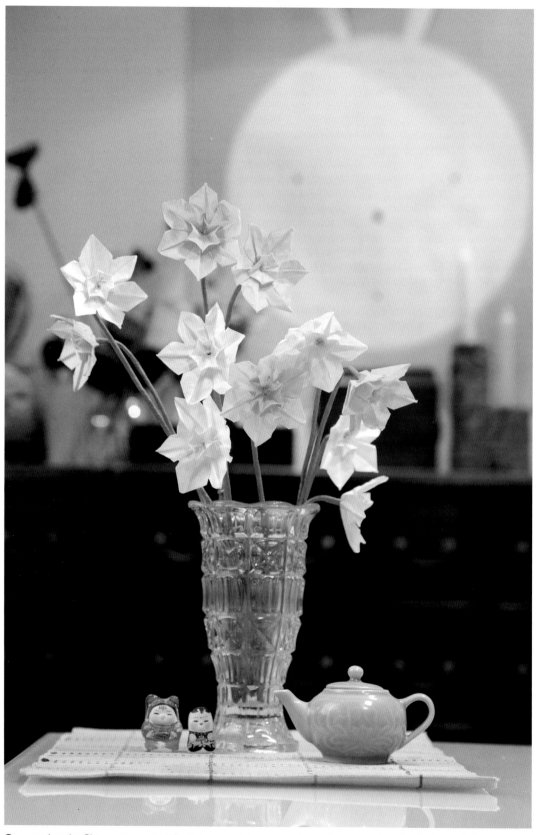

Compared to the Chinese narcissus, daffodils have much larger corollas. In the center there is a "sub-corolla." Their aroma is fresh and not as full-bodied as that of the Chinese narcissus.

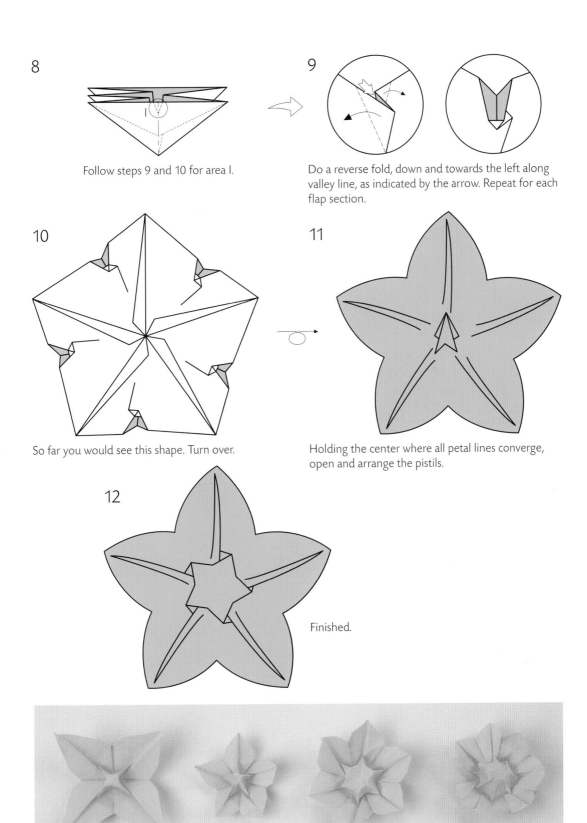

8

Follow steps 9 and 10 for area I.

9

Do a reverse fold, down and towards the left along valley line, as indicated by the arrow. Repeat for each flap section.

10

So far you would see this shape. Turn over.

11

Holding the center where all petal lines converge, open and arrange the pistils.

12

Finished.

Different effects using the square, pentagon, hexagon and octagon basic shapes.

## Creating Pistils of Different Sizes

The size of the pistil is according to the position of the valley line, as indicated by the step shown above. By adjusting the position of the valley line, you can adjust the size of the pistil for your flower. In the diagram, the section above the valley line will become the pistils, while the section below the valley line will become the petals.

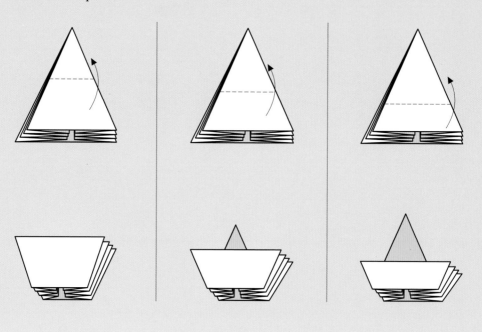

## Adjusting the Space between Petals

In step 5, the valley line that creates the trapezoid on the right side can be moved more to the left or more to the right. The position of the valley line will determine whether the basic shape created in Method 3, step 8 is a triangle or a trapezoid. This valley line position determines the space and angle between petals, and ultimately determines the shape of the final flower.

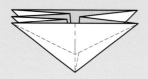 VS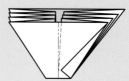

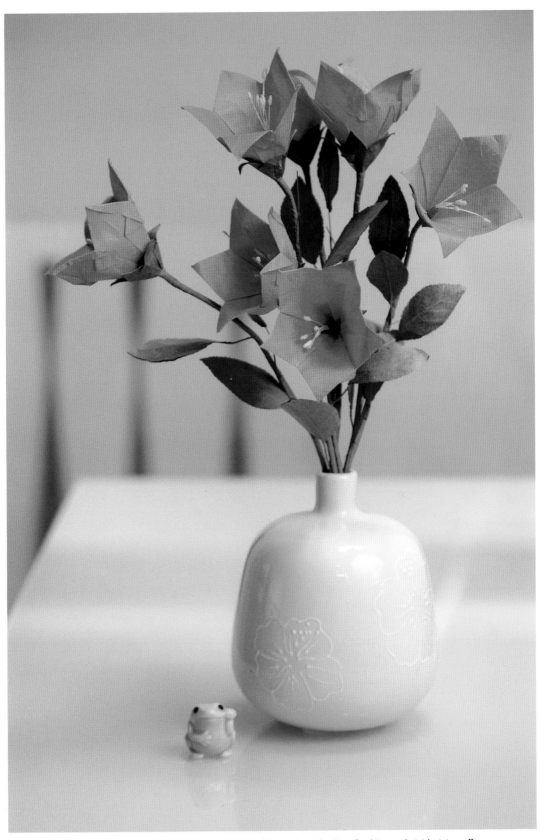

When the Chinese bellflower blooms, it looks like a monk's cap. Its color is refreshing and vivid, giving off a feeling of quiet, calm and comfort.

# CALYX

The green leaves on the outside of the corolla are called the calyx. Before the flower blooms, the calyx protects the bud; when the flower blooms, the calyx holds the bud and supports the flowering process. Each sheet is called a sepal; all the sepals come together to create a calyx.

The calyx can be either synsepalous or aposepalous: If the sepals are all joined together, the calyx is synsepalous. If the sepals grow completely separately from each other, the calyx is aposepalous.

## Synsepalous Calyx—Method 1

The calyx can be created using different regular polygons.

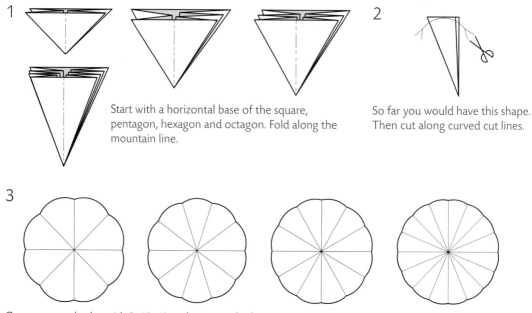

1

Start with a horizontal base of the square, pentagon, hexagon and octagon. Fold along the mountain line.

2

So far you would have this shape. Then cut along curved cut lines.

3

Open to reveal calyx with 8, 10, 12 and 16 curved edges.

## Synsepalous Calyx—Method 2

Use the instructions from page 25 to page 30 to create calyx shaped like pointed stars. This calyx is suitable for Chinese bellflower, azaleas and the dahlia.

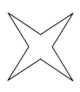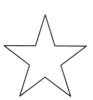

# Aposepalous Calyx—Method 1

The sepals created by this method are small and intricate, and are suitable for the rosacea family of flowers such as roses.

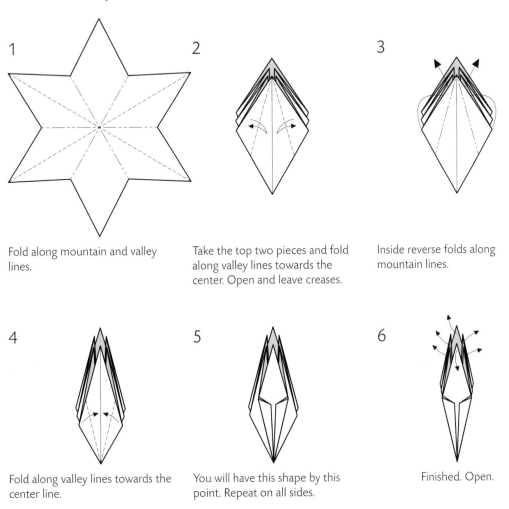

1

Fold along mountain and valley lines.

2

Take the top two pieces and fold along valley lines towards the center. Open and leave creases.

3

Inside reverse folds along mountain lines.

4

Fold along valley lines towards the center line.

5

You will have this shape by this point. Repeat on all sides.

6

Finished. Open.

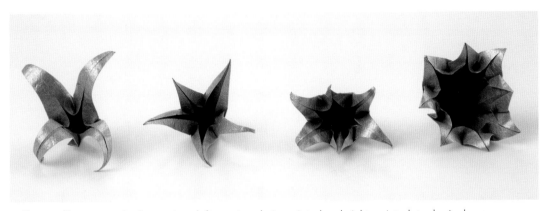

Different effects using the four-pointed, five-pointed, six-pointed and eight-pointed star basic shapes.

# Aposepalous Calyx—Method 2

This method creates a calyx that is thick, and is suitable for sunflowers. This method uses basic pointed star shapes.

1

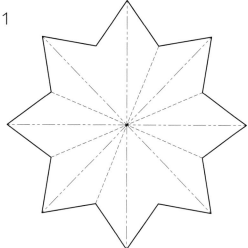

Fold along mountain and valley folds. Using the 8-pointed star with sharp edges, the sepals will be long and thin.

2

Fold up along valley line. Open to reveal crease line.

3

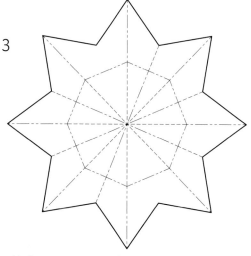

Fold along mountain and valley lines. You will have the shape shown in the next step.

4

Take the top layer and fold along valley line as indicated by arrow.

5

Fold down along valley line as indicated by arrow. Turn over and repeat on all sides.

6

Take the center protrusion and spread out and then press down to create a circular face. Mold into shape.

7

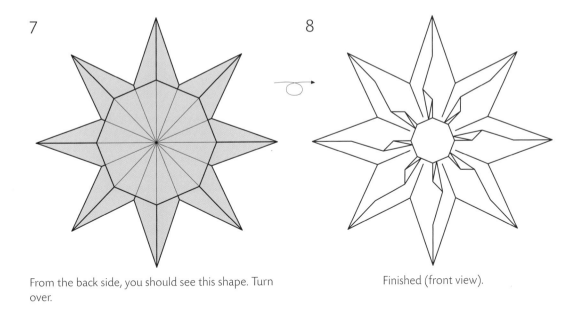

From the back side, you should see this shape. Turn over.

8

Finished (front view).

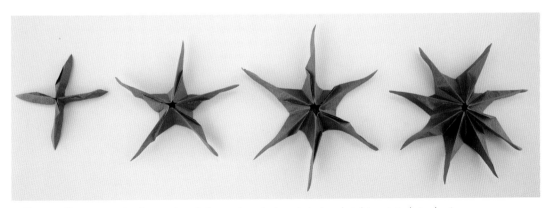

Different effects using the four-pointed, five-pointed, six-pointed and eight-pointed star basic shapes. Front view.

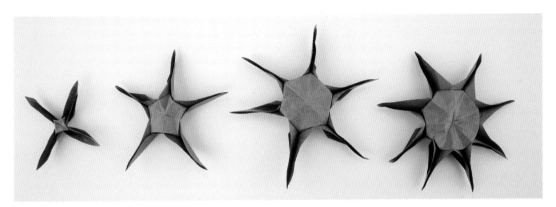

Back view.

# PISTIL AND STAMEN

Some pistil and stamen grow together while others grow apart. Pistil and stamen come in all shapes and sizes. Some flowers, such as radial-shaped flowers, will naturally create pistil and stamen as you fold them. Most flowers, however, will require thin wires, threads and stocking flower supporting materials, as well as colors to create pistils and stamens. Careful everyday observations plus imagination are required to bring pistil and stamen to life. In this section, we introduce the long thin dispersed type (lily, amaryllis, etc.), bundles (plum blossom, cherry, etc.) and cluster types (cineraria, chrysanthemum, etc.).

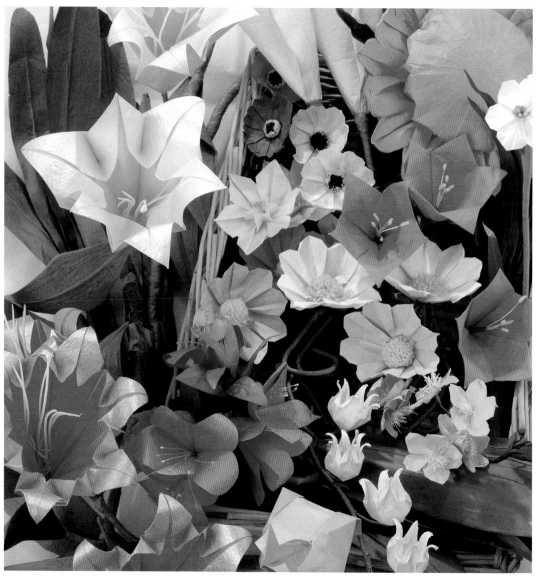

Different varieties of flowers have stamens and pistils in various shapes and rich colors. To create lively flowers requires careful observation. Use the techniques described in this book for elaborate creations.

# Long and Thin

Long thin dispersed type can be created using thin wires wrapped in color tape.

1. Glue a small bead on the tip of a wire.

2. Use color tape to secure the bead and the wire.

3. Repeat the above steps three times to create 3 wires with beads.

4. Hold the three wires tightly and wrap to secure.

5. Use color tape to wrap the three wires together.

# Bundles

Bundle type can be created using thin threads (such as polyester, cotton, etc.), white glue, thin wire and acrylic paints.

1. Prepare two thin cotton or wool threads. Dip finger in white glue and apply glue to wires. Let dry for later use.

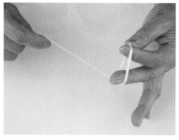

2. Once glue has dried, wrap thread around two fingers. Wrap a few more times to create a denser cluster of pistils.

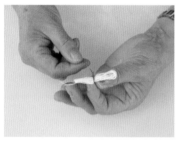

3. Wrap wire around the middle of the thread bundle. Tighten.

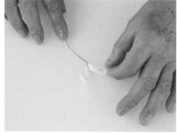

4. Fold thread bundle over midpoint.

5. Use another thread to wrap the bottom of the folded-over bundle.

6. Cut the top of the threads.

7. Use scissors to crop the top neatly. Wrap the bottom with color tape.

8. Color the top with acrylic paint, as desired, for a rich look.

# Clusters

Cluster type can be created using wire or wool mesh, thin wire.

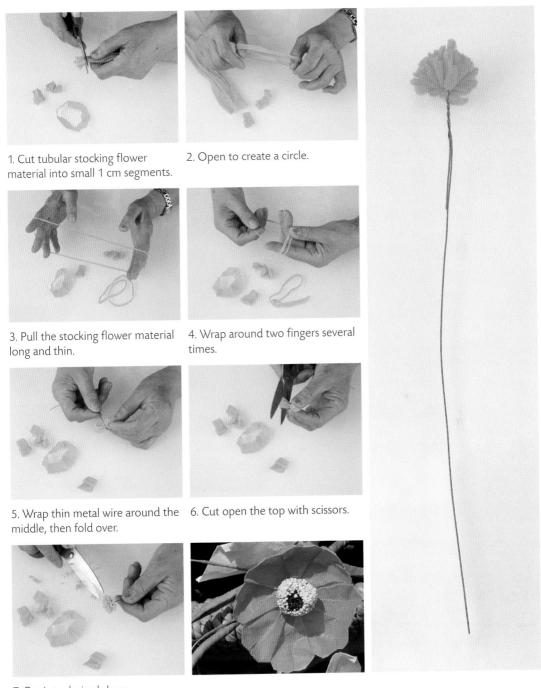

1. Cut tubular stocking flower material into small 1 cm segments.

2. Open to create a circle.

3. Pull the stocking flower material long and thin.

4. Wrap around two fingers several times.

5. Wrap thin metal wire around the middle, then fold over.

6. Cut open the top with scissors.

7. Cut into desired shape.

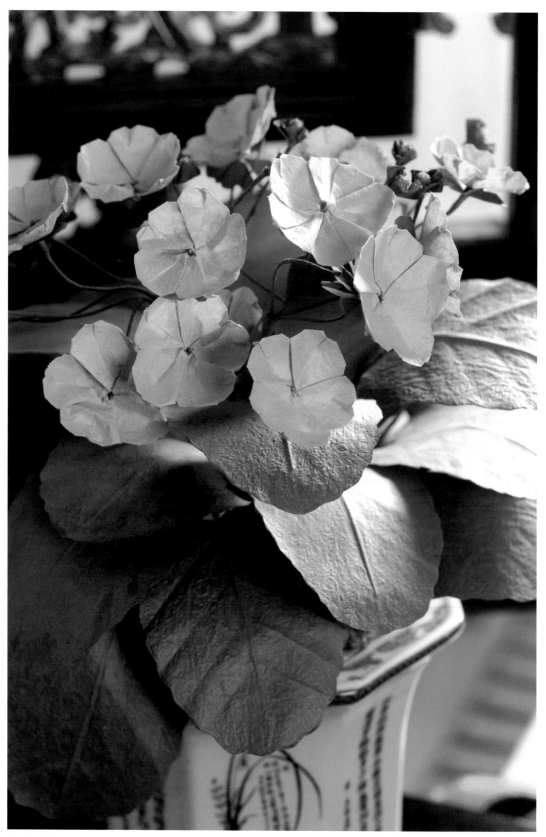

Petals of the primrose are rounded and blunt, with a basic heart shape; the edges are irregular and finely serrated. The primrose is considered a rotate flower. There is a wide variety, and colors include red, pink, yellow, white, purple, etc. Its unique bloom time in early spring is like an early announcement of the new season, therefore it is known as "greeting of spring."

# LEAF

The leaves on flowers come in a rich variety. Some are single leaves, while others have compound structures. "Opposites" are two leaves that form on a stem 180-degrees opposite each other. The leaves that form above and below are 90-degrees offset to avoid overlaying during growth. "Whorleds" are three or more leaves that grow on each stem segment in a radial pattern. "Alternates" are one leaf per stem segment. "Basal" are leaves that grow from the base near the roots of the flowering plant.

You can make leaves using tools, with a combination of cutting and folding. Be sure to bring out the unique characteristics of the leaf, such as veins and jagged edges. You can even use a needle to draw thin veins on the leaf surface.

Leaves can be categorized into long and narrow (of lily and orchid, etc.), and oval (of rose, etc.).

## Long and Narrow

1

Start with a square. Choose one corner and measure out three equal angles. Fold along valley lines as indicated by arrows.

2

Fold along valley lines as indicated by arrows.

3

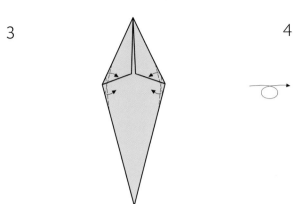

Fold corners along valley lines as indicated by arrows. Turn over.

4

Use needles to draw veins. Finished.

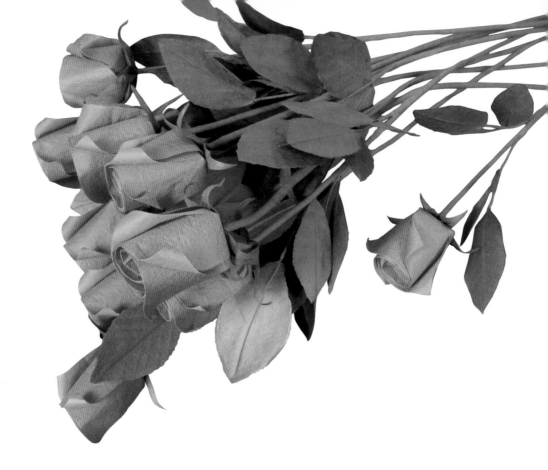

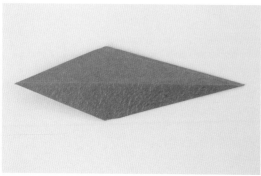

Front side.

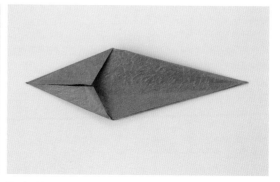

Back side.

## Using Tools

Some flowers, such as narcissus, have long oval leaves. These leaves can be created by directly cutting.

# Oval

This method is suitable for blades of leaves with smooth edges.

1

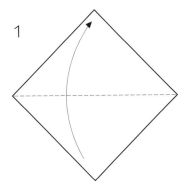

Fold up along valley line.

2

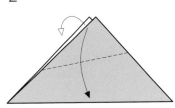

Fold down along valley line as indicated by arrow. Repeat on reverse side.

3

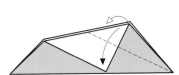

Fold down along valley line as indicated by arrow. Repeat on reverse side.

4

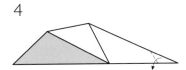

Fold down along valley line as indicated by arrow.

5

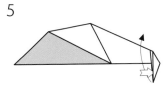

Open. Flip up as indicated by arrow. Flatten.

6

Open. Take the small triangle and reverse fold down along valley line as indicated by arrow.

7

Take the center and fold down along valley lines.

8

Finished.

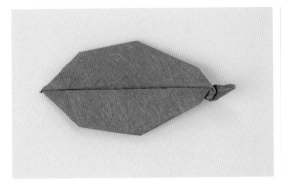

Front view.

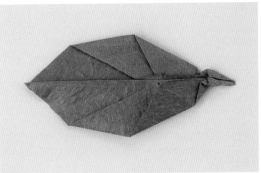

Back view.

This cutting method is relatively simple, suitable for leaves with serrated edges. With a bit of imagination, you can vary the sharpness and angles of the cuts, or add or subtract the number of folds, to create a rich variety of leaves.

1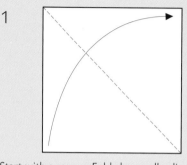

Start with a square. Fold along valley line as indicated by arrow.

2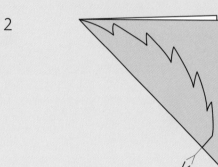

Draw cut lines as desired and cut.

3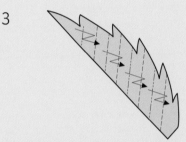

Pleat fold and open to create creases.

4

Open. Finished.

Leaves with different shapes and serrated edges.

# STEM

For short and thin stems, apply color tape directly onto metal wire. To create a thicker stem, wrap crêpe paper around metal wire before applying color tape. To create an even thicker stem, align two metal wires, wrap with crêpe paper before applying color tape over the entire bundle.

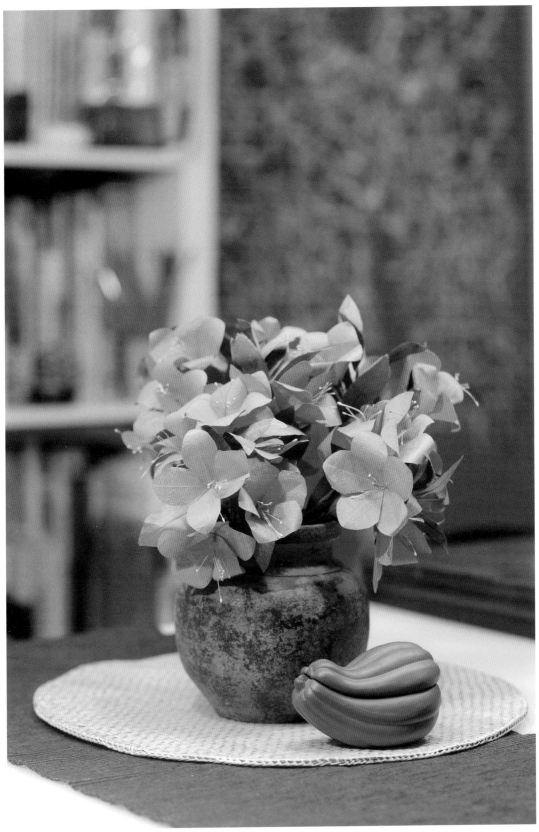

The azalea is one of China's Top Ten iconic flowers. The blossoms come in deep red, light red, rose, purple, white and many other colors. When brightly colored azaleas bloom, they cover entire mountains. The bold colors of azaleas signify a yearning towards harmonious living and a joyful future.

# Flower Assembly

When assembling each varietal of flowers, it is important to observe the placement of leaves and corollas on the stems in order to bring out a lively, realistic effect. Observe flowers in nature closely, and make note of how they appear throughout the four seasons, in order to discover their uniqueness from different perspectives. Then you can apply these discoveries to your artwork.

## Chinese Narcissus

Corolla: 6.5 × 6.5 cm or 7.5 × 7.5 cm solid-color textured paper in white. See page 119 for radial flower folding method.

Calyces: None.

Pistils and Stamens: See page 133 for how to make long and thin dispersed type. Also, using 2.5 × 5 cm textured paper in golden yellow, cut strips 3–4 mm wide and curl around pistils. Secure with glue.

Leaves: Green textured paper. See page 138 cutting method for long and narrow leaf; create several leaves in varying lengths.

Stems: Use metal wire 35–40 cm in length, wrapped in green color tape.

Assembly: Insert pistils, stamens and golden yellow strips into corolla and then secure the bottom onto the top end of stem, wrapped tightly with color tape. Each stem should have 1 or 2 corollas. Add 3–6 long and narrow leaves from the base (refer to pages 2–3 and 119).

## Plum Blossom

Corolla: 6.5 × 6.5 cm or 7.5 × 7.5 cm solid-color textured paper in soft pink. See page 115 for folding method on the left.

Pistils and Stamens: White or soft pink threads and thin metal wire. See page 134 for how to make pistils and stamens, then use yellow acrylic paint for the tips.

Leaves: None.

Stems: Brown.

Assembly: Insert pistils and stamens into corolla, then secure onto the top end of stem. Leaves are alternate. Each section of stem should have 1–2 flowers (refer to pages 18 and 64).

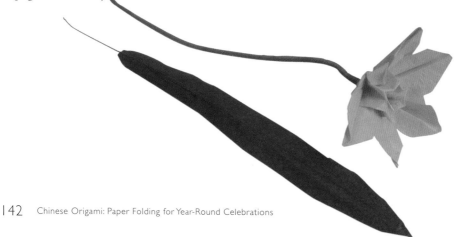

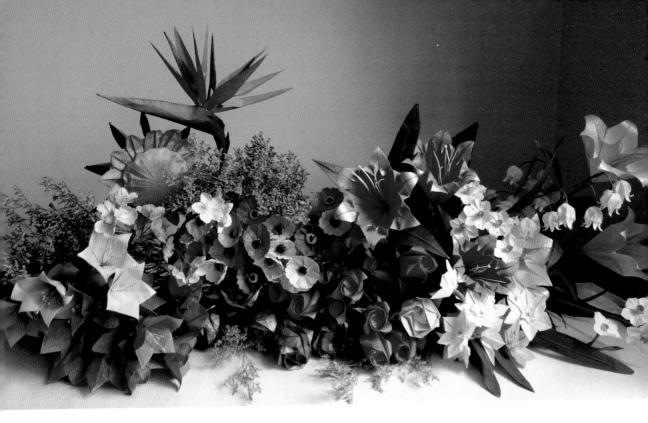

## Cineraria

Corolla: 8 × 8 cm solid color textured paper. Use regular octagon to start. See page 115 radial flower folding method on the right.

Calyces: None.

Pistils and Stamens: Use stocking flower material in several different colors. See page 135 method for cluster type.

Leaves: Green textured paper. See page 140 cutting method for heart-shaped leaves, with serrated edges.

Stems: Green.

Assembly: Create a hook on the top end of stem to wrap around pistils and stamens. Insert into corolla, then secure with color tape (refer to pages 24 and 116).

## Tulip

Corolla: 15 × 15 cm textured paper in various colors. See page 99 folding method for pot-shaped corolla.

Calyces: None.

Pistils and Stamens: Thin metal wire, small beads, color tape. See page 133 folding method for long and thin dispersed type.

Leaves: Green textured paper. See page 140 cutting method for oval leaves. Use needles to draw veins onto the leaves.

Stems: Green, 6–8 cm.

Assembly: Create a hook with the end of the stem to secure the pistils, stamens and corolla. Wrap crêpe paper around the stem to thicken, then wrap with green color tape. Tulip leaves grow from the base; secure the stem between two leaves (refer to page 98).

## Calla Lily

Corolla: 25 × 25 cm textured paper in yellow or light cream. See page 103 folding method for funnel-shaped flowers.

Calyces: None.

Pistils and Stamens: Wrap green crêpe paper around thin metal wire until thick; the end should be rounded. Wrap with yellow color tape.

Leaves (optional): Green textured paper. See page 138 for cutting method.

Stems: About 55–60 cm in length, green.

Assembly: Create a hook with the end of the stem and secure pistils, stamens and corolla. Secure with green color tape. Wrap crêpe paper around stem until thick, then wrap with green color tape to finish (refer to page 102).

## Amaryllis

Corolla: 25 × 25 cm textured paper in red. See page 105 folding method for funnel-shaped flowers.

Calyces: None.

Pistils and Stamens: Six pieces of thin metal wire, 13 cm each. One piece of thin metal wire, 15 cm. Three small beads. Red and yellow color tape. Each amaryllis contains 1 stamen and 6 pistils. Wrap red color tape around the six 13 cm wires, plus wrap the top 0.5 cm in yellow tape. Glue the three beads to the end of the 15 cm wire; wrap the top in yellow tape, then wrap the rest of the stamen in red tape.

Leaves: Green textured paper. See page 138 cutting method to make leaves 5.5–6 cm wide and 30–35 cm long. Cut the tip edge so it is pointy and round. Make 10–12 leaves.

Stems: Green and thick.

Assembly: Take a stem 50 cm long, hook one end and secure stamen, pistils and corolla. Attach 3 amaryllis buds to each stem. Wrap crêpe paper around stem until diameter of 0.7–0.8 cm, then wrap with green color tape. Amaryllis leaves grow from the base; secure leaves to the bottom of the stem (refer to page 104).

## Lily

Corolla: 30 × 30 cm square solid textured paper in light cream or yellow. See page 107 bell-shaped corolla folding method on the left.

Calyces: None.

Pistils and Stamens: Thin wires, small beads and color tape. See page 133 for long and thin dispersed type.

Leaves: 12.5 × 12.5 cm square green textured paper. See page 137 method for long and narrow leaves.

Stems: Thick metal wire wrapped in green color tape.

Assembly: Create a hook on the top end of stem to secure pistils, stamens and corolla. Add leaves in alternate pattern. Optional: spray with hairspray to keep shape (refer to page 108).

## Easter Lily

Corolla: 30 × 30 cm thick textured paper in red. See page 112 folding method for bell-shaped flowers.

Calyces: None.

Pistils and Stamens: Thin metal wire, small beads, color tape. See page 133 method for long and thin dispersed type. Color the tips with yellow paint.

Leaves: 12.5 × 12.5 cm green textured paper. See page 137 method for folding long and narrow leaves.

Stems: About 50–60 cm. Green.

Assembly: Create a hook with the end of stem to secure the pistils, stamens and corolla. Wrap stem with crêpe paper to increase the diameter, then wrap with green color tape. Add leaves in the alternate method (refer to page 111).

## Bell Orchid

Corolla: 7.5 × 7.5 cm thick textured paper in white. See page 113 for bell-shaped flower folding method.

Calyces: None.

Pistils and Stems: Since bell orchids hang downward, pistils and stamens cannot be seen, so there is no need to make them.

Leaves: Green textured paper. See page 140 cutting method. Bell orchid leaves are large ovals, usually 2 or 3. Use tools to draw veins.

Stems: Green, 6–8 cm.

Assembly: Create a hook with the end of stem to secure the corolla. Each stem can accommodate 6–10 bell orchid buds. Place each stem between two identical leaves and secure (refer to page 114).

## Chrysanthemum

Corolla: 15 × 15 cm textured paper in yellow, purple, red and white. Use regular hexagons. See page 121 method for radial flowers.

Calyces: 3.5 × 3.5 cm green textured paper. See page 128 method for 6-pointed star calyx.

Pistils and Stamens: Yellow threads, thin metal wire. See page 135 method for creating pistil clusters.

Leaves (optional): Green textured paper. See page 140 method for oval leaves; edges are serrated.

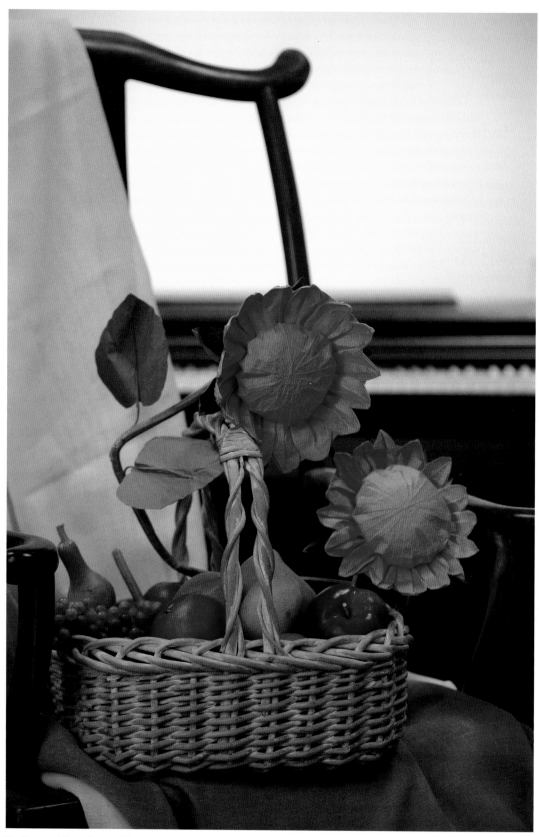

Sunflowers follow the sun. The round basin face is large; the plant is thick and strong and is suitable for decorative display. They symbolize a love for life.

Stems: Green.

Assembly: Gather pistils, stamens and corolla first, and then create a hook with the top end of stem to secure pistils, stamens and corolla. Wrap stem with crêpe paper to thicken diameter, then wrap with green color tape. Add leaves, one at a time in the alternate pattern (refer to page 120).

## Daffodil

Corolla: 7.5 × 7.5 cm or 8 × 8 cm solid color textured paper in yellow and white, or other colors. See page 123 for folding method.

Calyces: None.

Pistils and Stamens: Pistils and stamens are part of the daffodil corolla. Optional: Use one ready-made stamen on one corolla for decoration.

Leaves (optional): Green textured paper. See page 138 cutting method for long and narrow leaf.

Stems: Green and thick.

Assembly: Take a stem 40 cm long, hook one end and secure the ready-made stamen. Insert the end without the stamen through the center of corolla and secure the bottom of the corolla with the wire. Wrap with green color tape. Secure leaves to the bottom of the stem (refer to page 124).

## Chinese Bellflower

Corolla: 15 × 15 cm textured paper in pink or red. See folding methods for funnel-shaped corollas on page 105.

Calyces: 7.5 × 7.5 cm green textured paper. See page 128 method for 5-pointed star calyx.

Pistils and Stamens: Thin metal wire, small beads, and color tape. See page 133 method for long and thin dispersed type.

Leaves: Green textured paper. See page 140 method for oval leaves, with serrated edges.

Stems: Green.

Assembly: Create a hook with the stem and secure pistils, stamens, corolla and calyces. Leaves grow in the alternate pattern. Each stem can have a single flower or several flowers growing together (refer to page 127).

## Primrose

Corolla: 7.5 × 7.5 cm or 8 × 8 cm solid color textured paper in deep red or light purple.  See page 115 for radial flower folding method on the right.

Calyces: None.

Pistils and Stamens: None.

Leaves: Green textured paper. See page 140 cutting method for oval leaves. Note that the leaves for the primrose are long and round and the edges have bumps.

Stems: Green.

Assembly: Create a hook with the top end of the stem to secure pistils, stamens, calyx and corolla. Use green color tape to bundle the basal leaves with the stem (refer to page 136).

## Azalea

Corolla: 12 × 12 cm solid-color textured paper in deep rose, red, or other colors. See Page 110 for bell-shaped flower folding method.

Calyces: Green textured paper. See page 128 synsepalous folding method to create a 5-pointed star calyx.

Pistils and Stamens: Small wires and small beads. See page 133 for long and thin dispersed type. Add yellow color to the tips.

Leaves: Green textured paper. See page 139 oval leaves folding method for smooth-edged leaves.

Stems: Green.

Assembly: Create a hook on the top end of stem to wrap around pistils and stamens. Insert into corolla, secure with color tape. Secure leaves in alternate pattern around the stem (refer to page 141).

## Sunflower

Corolla: 30 × 30 cm thick textured paper in yellow or orange. Use hexadecagon. See page 123 method for making radial flowers.

Calyces: 30 × 30 cm and 6 × 6 cm green textured paper. See page 130 method to create 8-pointed aposepalous calyx. Use the 6 × 6 cm green textured paper to create a small 8-pointed star calyx with the method on page 128.

Pistils and Stamens: Pistils and stamens are part of the sunflower corolla, so there is no need for separate pistils.

Leaves: Green textured paper. See page 140 cutting method for oval leaves.

Stem: Green and thick.

Assembly: Place foam material into the folded sunflower corolla, so the pistils and stamens look more full and will hold its shape better: Cut a piece of hard foam into a round, 9 cm diameter and 1.5–2 cm thick. Apply glue. Insert metal wire through the center of the foam round; where the wire comes out, secure by bending into hook shape. Insert into sunflower corolla. The purpose is to keep the sunflower erect. Place the large and small calyx on the bottom of the sunflower, secure with glue. Sunflower leaves grow in alternate pattern; secure leaves and stems with green color tape (refer to page 146).

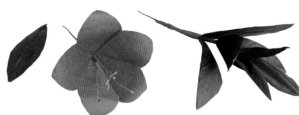